IMAGES
of America

NORTH ROYALTON

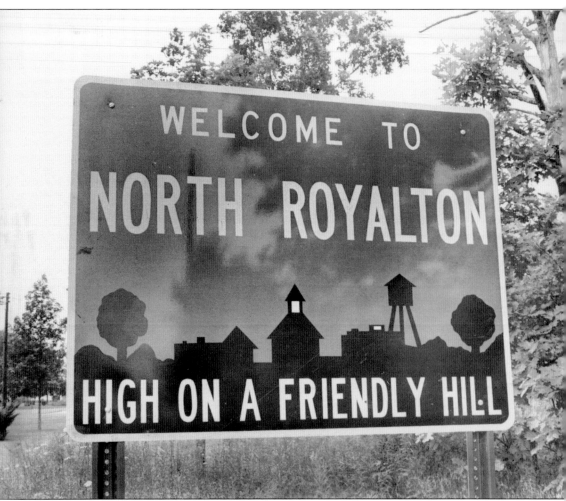

NORTH ROYALTON, OHIO. This road sign shows one of the few nicknames given to the city, "North Royalton, High on a Friendly Hill," created by resident Ed Fisher, an announcer at television station WJW. North Royalton was also known as the "City of Hills and Valleys," because on a good day residents could see all the way to Strongsville. (Courtesy of North Royalton Historical Society.)

ON THE COVER: **NORTH ROYALTON CHEERLEADERS.** In this c. 1960 photograph are, from left to right, Maxine Imhoff, Carol Thuce, Dottie Keeling, and Jane Rossborough showing their school spirit. The North Royalton cheerleaders date back to the 1940s. In 1946, the cheerleading squad included Bob Willard, the first male cheerleader for North Royalton. (Courtesy of Cleveland Press Collection.)

IMAGES
of America

NORTH ROYALTON

Diana J. Eid

ARCADIA
PUBLISHING

Copyright © 2012 by Diana J. Eid
ISBN 978-0-7385-9391-3

Published by Arcadia Publishing
Charleston, South Carolina

Printed in the United States of America

Library of Congress Control Number: 2012933592

For all general information, please contact Arcadia Publishing:
Telephone 843-853-2070
Fax 843-853-0044
E-mail sales@arcadiapublishing.com
For customer service and orders:
Toll-Free 1-888-313-2665

Visit us on the Internet at www.arcadiapublishing.com

To my wonderful husband, Adam

CONTENTS

ACKNOWLEDGMENTS

I had so much fun writing this book because it brought back so many memories for me. First, I would like to thank the residents of North Royalton for all of their generous help sharing their photographs and memories with me. I had a great time meeting with every one of you and listening to your family stories.

I would also like to thank the members of the North Royalton Historical Society for letting me look through their archives. They are a wonderful and fun group dedicated to keeping the history of North Royalton alive, and I am so glad to be a part of them. Special thanks to Don and Pat Harris and Diane Papay for taking the time to let me sift through photographs and documents. Walt Zimlich was also a great help and provided me with a lot of information.

Thank-you to Sara Macho of the *Sun News* and Jaime Anton of *The North Royalton Post* for spreading the word about my project.

I am grateful to Jim Presot for providing me with much-needed information about the history of North Royalton schools—you definitely helped to fill in many of the gaps.

Many thanks to editors Sandy Shalton and Simone Monet-Williams from Arcadia Publishing.

To my book buddy, I still miss you every day.

A big thank-you to my brother, Rich, for helping me with a few of the photographs I really wanted to use. I also want to thank my dad, Richard, and my sister, Charlene, for helping me out with the book when I needed some advice and time off.

Finally, I would like to thank my mother, Susan, for her help and support once again. Even though it was easier this time around, I could not have done it without you. Thank-you for being there any time I needed you and for getting those photographs I just could not do without. You are an awesome mom.

INTRODUCTION

Imagine traveling away from all that you are familiar with and arriving in an area you know nothing about with no one else around and no idea where basic necessities such as water are. Try to picture North Royalton not as an area full of schools, homes, and businesses, but as a thicket of dense brush with no paths to follow. This is what the first man to arrive in the area experienced. That man, Melzer Clark, traveled to Royalton and in 1811 settled at what is now the corner of Boston and Broadview Roads. Clark married Almira Paine, the daughter of Seth Paine, a land agent in Brecksville.

The two newlyweds settled into Royalton Township and were the only two people in the township for several years. Not until 1816 did more families begin arriving from distant locations to settle into the area. The second family to arrive was the Robert Engle family, along with Engle's father-in-law, John Shepherd, who was 88 years old at the time. Early stories describe him as a very active man in his later years; he lived to the remarkable age of 117.

At the end of 1816, the Thomas Francis family arrived and stayed with the Engle family until they built their own house. The next year, even more families arrived, including David and Knight Sprague. By 1818, there were enough people in the area to form a township government. In November 1818, a meeting was held at Robert Engle's home, and Royalton became a separate settlement.

One of the more interesting early settlers was John Coates, also known as Uncle Jackie Coates. He owned a 300-acre farm in New York, which he traded for 3,400 acres of land in Royalton and $1,000. He settled in an area on Wallings Road between Broadview and State Roads. In the early days, the intersection of Wallings and State was known as Coates Corners. Coates was said to have chosen this particular spot because it reminded him of where he grew up in England.

Another well-known man who moved to Royalton was Jonathan Bunker, whose relatives fought in the Battle of Bunker Hill. Bunker left New York with his friend Boaz Granger, who stopped in the area where Conneaut is now located while Bunker continued on. He arrived in Royalton in the morning and had a shanty put up by nighttime, working day and night for eight months to clear the land and build a cabin. He then sent for his family, who arrived with Granger. Later, Granger built Bunker's house in 1827—the first frame house in Royalton.

Royalton was named by the Sprague brothers, David and Knight. It is said that at the first meeting, when a name was to be chosen, the brothers offered the township a gallon of whiskey to name the area Royalton after their hometown in Vermont. The townspeople agreed, and Royalton was born. It was not until many years later, around 1885, that "North" was added because of another town called Royalton in southern Ohio.

Knight Sprague had been a blacksmith and been blinded in an accident. This did not stop the townspeople from electing him fence viewer in 1821, and he was credited with building the first town hall on the village green. The Baptist Church and the Independent Order of the Odd Fellows Lodge also built their first meeting places on the green. There was also a cemetery located

on the green, later moved to the cemetery now on Royalton Road. Stories say that the graves of those who died of smallpox were never moved and still remain on the green today.

Abraham Teachout Sr. and his family arrived in 1837. His son Abraham Jr. wanted to build a sawmill, so he gathered a crew together. In those times, whiskey was often used to raise the spirits of the workers, and after the sill was in place they called for the liquor to come out. Teachout then told them this would be a temperance raising, meaning that it would be done without alcohol. The men put up a fight, saying the rest of the sawmill could not be built without whiskey. Teachout then got on a platform and delivered a speech about temperance, telling them if they could not do the work without liquor, they could go home. Instead of whiskey, a big meal was prepared for the men after the work was complete. Everyone had a good time, and the men excitedly went home to tell their wives about what had happened. The mill was put up and completed in 1845.

Dairy was the main industry in Royalton Township primarily because the soil was found to be too poor for farming crops. By the 1860s, Royalton was thriving as a dairy center. There were two creameries: one on Ridge Road and the other at the corner of York and Bennett Roads. These businesses collected milk from farmers and made it into butter, among other products, to be sold in Cleveland.

Many general stores also thrived in the area, selling everything from food to sundries. When residents of the township were not able to pay, the storekeepers let them buy items on credit. Whenever the people could afford their bill, they made sure to pay it.

In 1927, North Royalton became a village, and in the 1950s and 1960s it really started to grow, with more schools added to the area and businesses popping up all over the place. North Royalton officially became a city in 1961. Today, it is a thriving community with a great focus on education and schools.

This book will take the reader back to the earliest days of North Royalton, when Harvest Picnics were all the rage and the only telephones were at general stores. It was a time when doctors traveled on foot or horseback and homes were considered mansions. The North Royalton of yesteryear was completely different than it is today, but the hard work of early settlers and residents have made the city what it is today: a community with a sense of pride and togetherness.

One

EARLY ROYALTON

In 1811, the first settler, Melzer Clark, arrived in the southeast part of Royalton Township, which was under the jurisdiction of Brecksville at the time. When Clark arrived, the area was heavily wooded and there were no paths, so he had to cut out areas by slashing (cutting down everything around and letting it rot), which helped clear the area quickly and also provided humus for the soil.

The next group of settlers did not arrive in the area until 1816. Not much is known as to why no one arrived for five years, but some suspect that because of the war with England, no other attempts to settle in Royalton were made until it was over.

Shortly after the next group of settlers came to Royalton, the township began to grow, and it became a separate township in 1818. Businesses, schools, churches, and more homes were put up in the area over the years.

The first male child born was Lorenzo Carter, and the first female child was Rhoda Francis; both were born in 1816. The first frame building was constructed by Boaz Granger around 1827, and the first death in the township was that of Catherine Coates.

North Royalton started as a small dairy center with only a few residents, but over time it grew into a lively city.

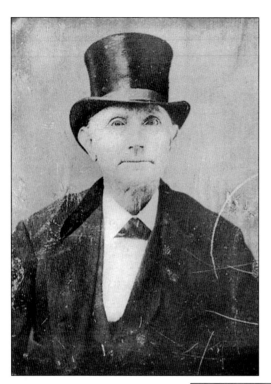

ROBERT ENGLE SR. Engle came to Royalton from New York in June 1816 with his family, which included his father-in-law, John Shepherd, settling a half mile from the center of the township. The first township meeting was held in Engle's home on November 9, 1818. (Courtesy of Bonnie Nilsen for johnshepherdfamily.com.)

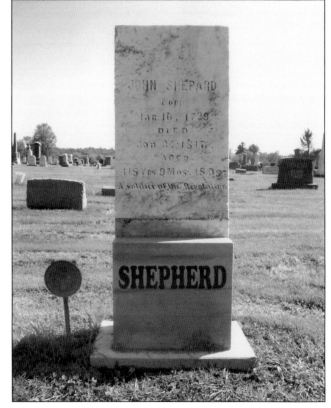

JOHN SHEPHERD GRAVE. John Shepherd is believed to have died at the age of 117 in 1846, making him the oldest surviving veteran of the American Revolution. He was 88 years old when he came to Royalton. His grave in the North Royalton Cemetery has a small historical marker next to it. (Courtesy of Susan Eid.)

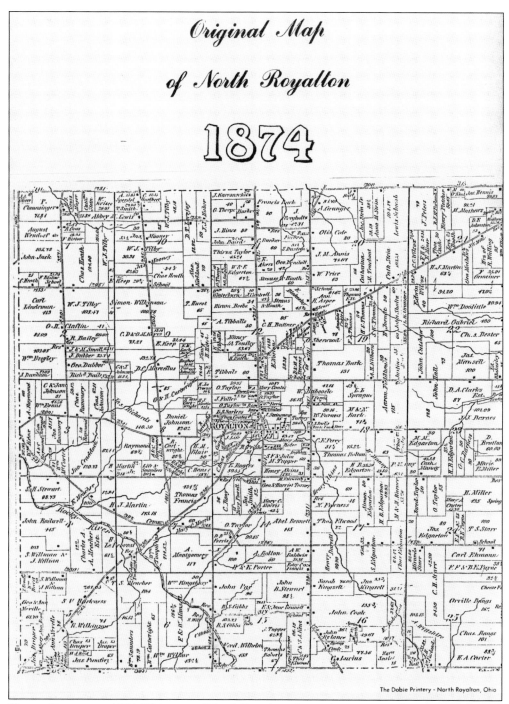

NORTH ROYALTON, 1874. This map of North Royalton shows the portions of property each early settler owned. The township was divided into 25 sections, with each section one square mile long. It stayed this way until 1928, when one of the sections in the eastern end became a part of Broadview Heights. The middle of the map, around the village green, had the most business activity and was known as the Business Center. (Courtesy of North Royalton Historical Society.)

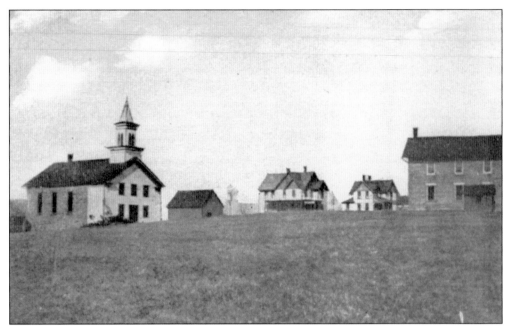

VILLAGE GREEN, 1905. Looking north from Royalton Road, the town included, from left to right, the North Royalton Baptist Church, the Fairview Hotel barn, the Fairview Hotel, the Veber house, and city hall and its coal shed. Around this time, it was typical for churches to be completely full on Sunday nights, as it was the only place for men to take their best girl. (Courtesy of North Royalton Historical Society.)

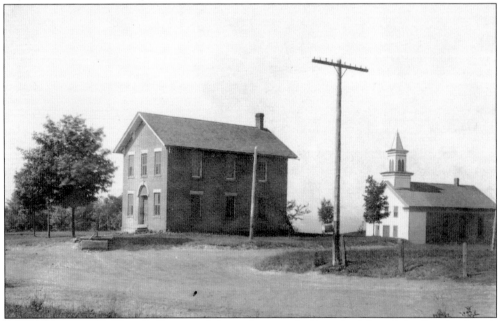

EARLY RIDGE ROAD. This 1905 postcard shows the town hall on the left and the Baptist church on the right. The town hall was built in 1870 at a cost of $2,960 and was used as a school until the high school was built on Royalton Road. The class of 1907 graduated from this town hall. (Courtesy of North Royalton Historical Society.)

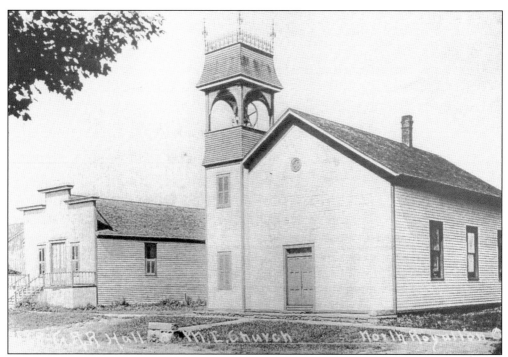

GAR HALL/METHODIST CHURCH. The Grand Army of the Republic Hall, on the left, was a meeting place for union Civil War veterans, and it held social events. It was later replaced by the Independent Order of Odd Fellows Hall. The Methodist church is on the right. (Courtesy of North Royalton Historical Society.)

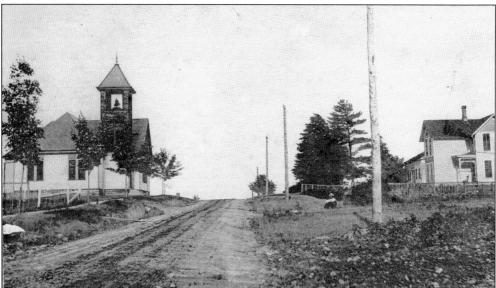

EARLY TOWNSHIP. Looking east on Royalton Road around 1900, the Disciple Church, also known as the "Church on the Hill," is on the left. At the time, all of the churches in town gathered together and held Christmas Eve programs, where everyone sang songs and gave readings. There were gifts for every resident and always a box of candy and an orange for each child. (Courtesy of North Royalton Historical Society.)

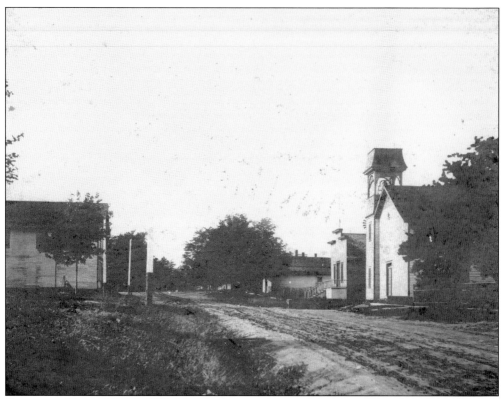

CENTER OF TOWN. This c. 1885 photograph was taken at the center of Royalton Township and shows Ridge Road, called Center Road at the time. On the left is the town hall, and on the right (from front to back) are the Methodist Episcopal Church, the GAR Hall, and the S.W. Thomas General Store. (Courtesy of North Royalton Historical Society.)

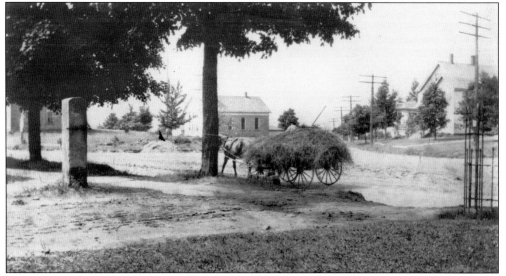

DAILY WORK. Sherman Thomas stands with a load of hay with the Baptist church in the background and the town hall to the left. Many families walked or rode a buggy to the Baptist church on the village green. (Courtesy of North Royalton Historical Society.)

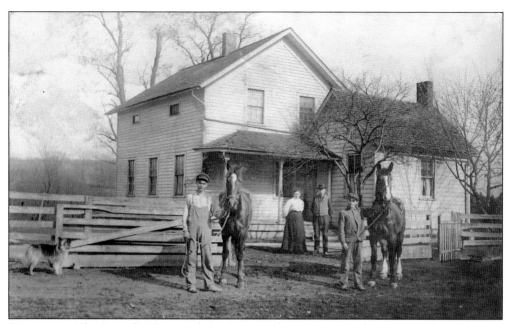

FARMHOUSE. The Pinta family owned this 120-acre dairy farm on Ridge Road south of Edgerton Road. From left to right are William (with horse), Anna, James, and Fred Pinta. At the age of 21, Fred was drafted into the US Army. After his service, he continued farming the family land. (Courtesy of North Royalton Historical Society.)

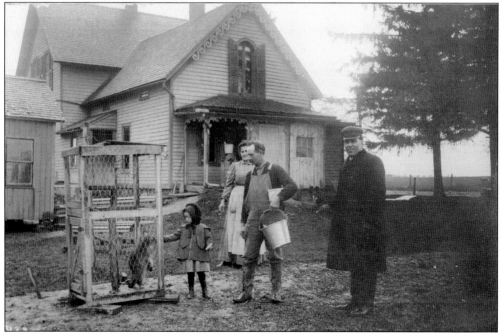

HELPING OUT AT THE FARM. Yaro Stadnick, standing on the right in the black coat, built the general store at the corner of Royalton and State Roads and was in business for about two years before selling it to Edward Cerny. Stadnick was also treasurer of Royalton Township. (Courtesy of North Royalton Historical Society.)

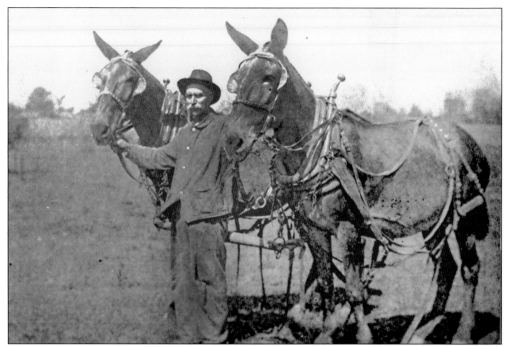

TEAM OF MULES. Herb Sherwood stands next to his mules in the early 1900s. In 1870, Orasmus Sherwood, a relative of Herb's, built a new brick town hall to replace the original one constructed by Knight Sprague; he was paid $2,985 for his work. Years earlier, in 1851, he built a schoolhouse and two outhouses on Edgerton Road for $300. (Courtesy of North Royalton Historical Society.)

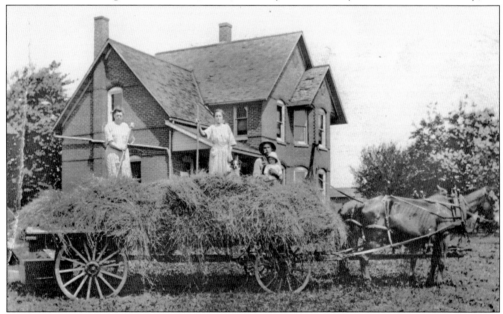

WORKING ON THE FARM. The people standing on the hay pile are identified as, from left to right, Grandma Sherwood, Grandma Hoffman, unidentified, and Baby Sherwood. Hay was usually sold for profit or stored and used to feed the farm animals. Processing hay was a multi-step activity. (Courtesy of North Royalton Historical Society.)

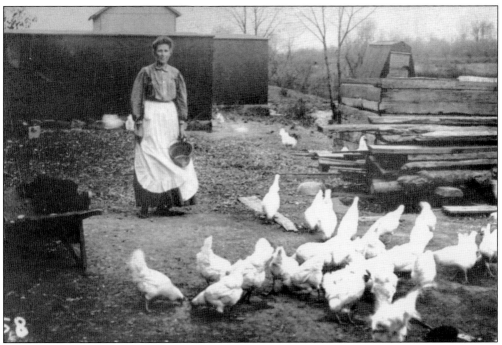

FEEDING CHICKENS. Esther Ellsworth, seen here feeding her chickens, and her husband, Elmer, owned a small farm near State and Royalton Roads. Elmer ran the first repair shop for wagons and carriages and also had a part in building the bandstand on the village green. (Courtesy of North Royalton Historical Society.)

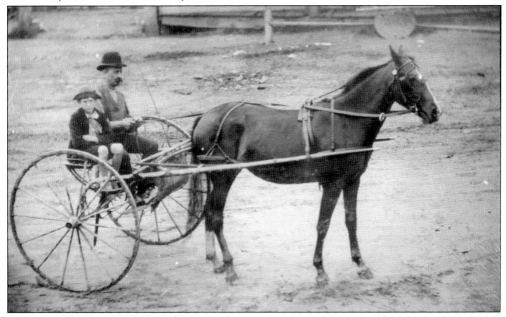

RIDING IN A SULKY. J.N. Veber and his son Bert ride in a sulky, a two-wheeled, single-seat cart used for transport. It generally seated one person and was used by those who usually traveled alone, such as doctors. It allowed a person to travel quickly because of its ease of use and reduced strain on the horse. (Courtesy of North Royalton Historical Society.)

SARDIS EDGERTON JR. Sardis Edgerton Jr. was born on June 8, 1839, and learned the bricklayer and plasterer's trade. He was a Republican, and his first presidential vote was cast for Abraham Lincoln. He and his wife were members of the North Royalton United Methodist Church. (Courtesy of North Royalton Historical Society.)

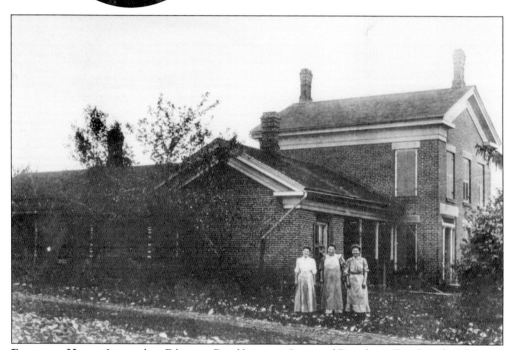

EDGERTON HOUSE. Located on Edgerton Road between State and Broadview Roads is the Edgerton home. Standing in front of the house are, from left to right, Nora Cartwright Edgerton, Naoma Cartwright Bailey, and an unidentified woman. This area was also the site of a large dairy farm and a sawmill in the 1830s. (Courtesy of North Royalton Historical Society.)

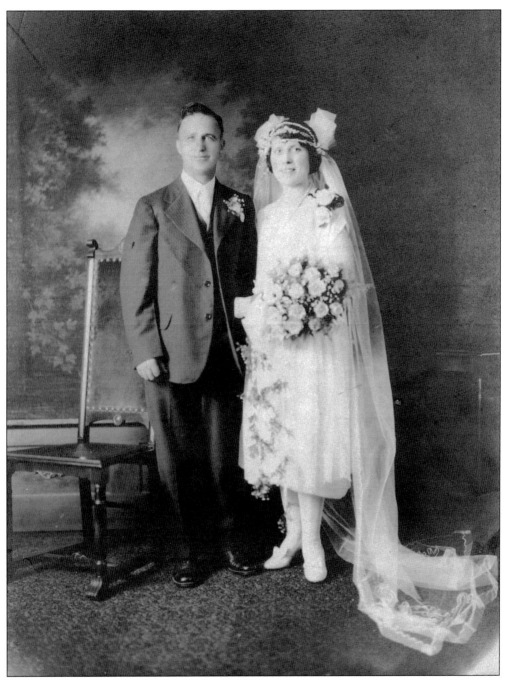

WEDDING PHOTOGRAPH. Christine Miller Robb stands next to her new husband in this early wedding photograph around 1920. They lived on Bunker Road at the time. The women's liberation movement was gaining strength at this time, and many women wore short haircuts as a way of liberating themselves. Because of their hairdos, a veil was an important way of expressing a woman's femininity on her wedding day. These types of veils, called cap veils, were made popular in the 1920s and became more elaborate as the years went on. (Courtesy of North Royalton Historical Society.)

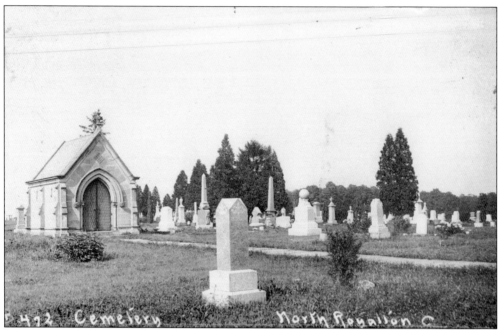

NORTH ROYALTON CEMETERY. This postcard shows the cemetery on Royalton Road. The first cemetery in Royalton was located on the village green. After a smallpox epidemic, most of the graves were moved to this cemetery; however, some say there are still graves on the village green that were never relocated. (Courtesy of North Royalton Historical Society.)

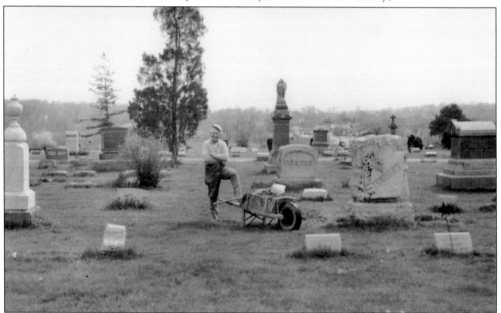

CEMETERY CARETAKER. Glenn Bailey, the custodian for the North Royalton Cemetery, poses with his wheelbarrow in the cemetery, which opened in 1866. The cemetery holds the graves of many early settlers and is also the site of the Soldier's Monument, which honors Royalton's Civil War veterans. In the early 1900s, a cemetery committee was formed to keep it in good condition. (Courtesy of North Royalton Historical Society.)

PRITCHARD CEMETERY. This cemetery on Edgerton Road, named after Thomas Pritchard, who owned land nearby, was the first burial ground in Royalton Township. The earliest burial was in 1818 and the last was in 1887. Early settler Knight Sprague is also buried in this cemetery. (Courtesy of Susan Eid.)

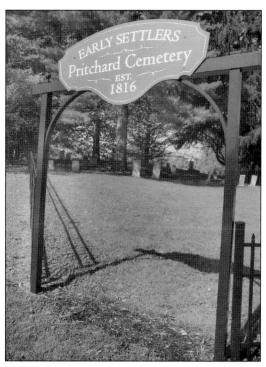

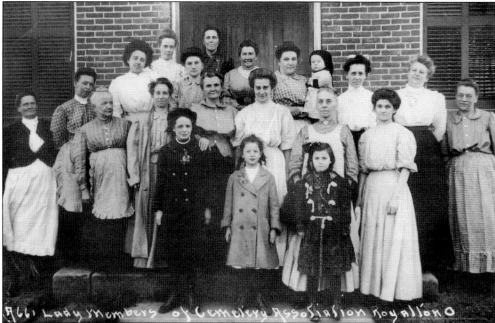

CEMETERY ASSOCIATION, 1909. The Cemetery Association, whose job it was to keep up the cemetery on Royalton Road, included, from left to right, (first row) Bernice Holly, Martha Tryon, and Hazel Searles; (second row) Em Veber, Rosa Haas, unidentified, Mrs. Kellum, Mrs. Zerbe, and Kate Veber; (third row) Mrs. Kingsbury, Mrs. Hamblin, Grandma Veber, Mae Ingram, Kit Searles, Naomi Bailey, Esther Ellsworth, Mrs. Carter, Nora Edgerton, Mrs. Stadnick, Mrs. Ingram, and Mrs. Cady. (Courtesy of North Royalton Historical Society.)

READY FOR WORK. Shown here is the Searles house at the corner of Royalton and State Roads. At this time, State Road was made of dirt; it was paved in 1909. Yaro Stadnick kneels with a dog as the team gets ready to plant crops. (Courtesy of North Royalton Historical Society.)

ON THE FARM. Edward Bassett (left) poses on his horse at the Searles farm at the corner of State and Royalton Roads. This area later became the site of the Searles and Bassett funeral home. Before these businesses came along, services were usually held in the family home. A black wreath was usually hung on the front door as a sign that the family was in mourning. (Courtesy of North Royalton Historical Society.)

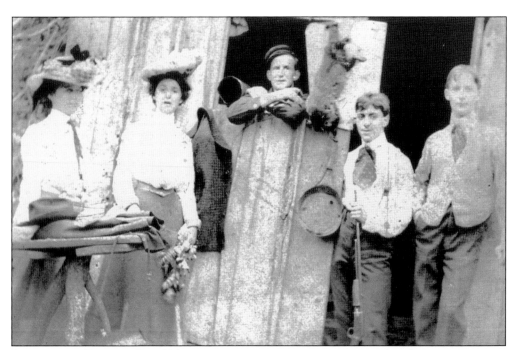

Posing for a Picture. Bert Veber (center) poses for a photograph with friends. Veber was later elected council president pro tem and was responsible for North Royalton's first village ordinance. (Courtesy of North Royalton Historical Society.)

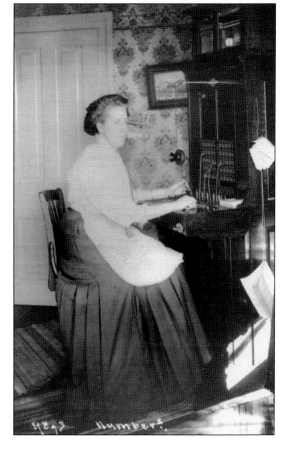

Royalton Switchboard, 1909. Anna Allen sits at Royalton's first switchboard. Royalton was part of the Berea Exchange and was serviced by the Ohio State Telephone Company until 1921, when it switched to the Ohio Bell Telephone Company. The first switchboard in Royalton was in the home of Etta and Fred Ellsworth across from the North Royalton Cemetery. If the telephone lines needed to be fixed, repairmen would board with the Ellsworths until the work was done. (Courtesy of North Royalton Historical Society.)

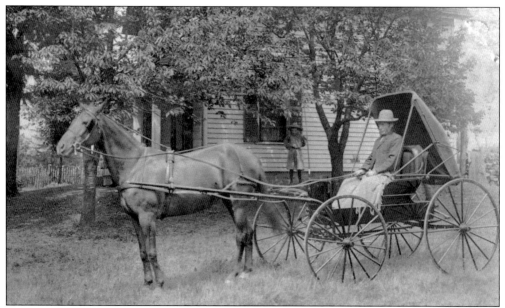

HORSE AND BUGGY. Clayton Akins, who served North Royalton as marshal and police chief for 28 years, rides behind his horse. Atkins was elected marshal in 1930, and in 1938 he was elected chief of police, where his duties also included being a school guard, animal warden, and chauffeur for city officials. He retired as police chief in January 1958. (Courtesy of North Royalton Historical Society.)

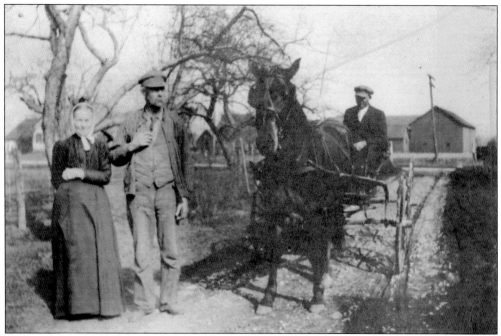

EARLY ROADS. Farm wagons and carriages were the first vehicles in Royalton, mainly used as produce wagons going door to door selling products. Chief Jack D. Reader is seen here sitting in the carriage. Reader was a police officer for North Royalton in 1942 and became chief in 1958 when Clayton Akins retired. (Courtesy of North Royalton Historical Society.)

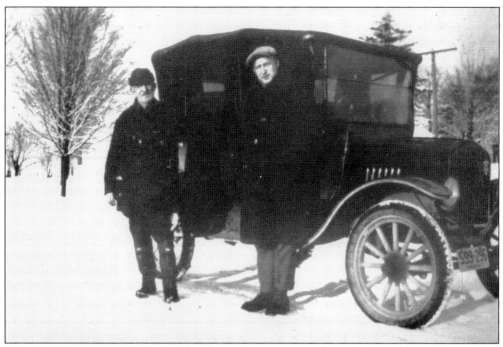

EARLY AUTOMOBILE. George Haas (left) and Bert Veber stand next to one of the earliest cars in town. Haas was one of the first elected constables. There was little crime in Royalton in the early days, so constables usually had nothing to do. (Courtesy of North Royalton Historical Society.)

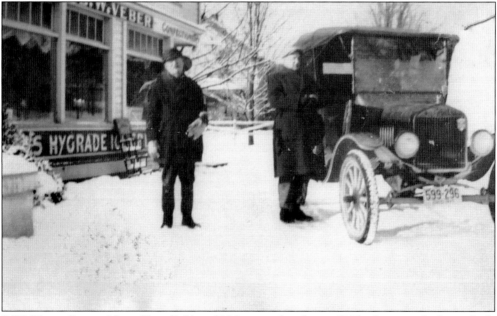

B.W. VEBER STORE. Here, Haas (left) and Veber stand in front of Veber's store, which was built around 1920 and was known for its ice cream above all else. At one time, it was known as B.W. Veber's Sweet Shoppe and sold chocolates, high-grade ice cream, and fancy groceries. (Courtesy of North Royalton Historical Society.)

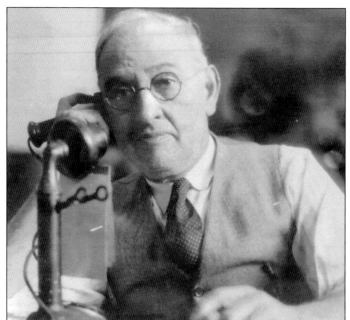

ROYALTON'S FIRST MAYOR. In 1927, E.C. McCombs became North Royalton's first mayor, receiving an annual salary of $400. McCombs was also president of the Royalton Township Improvement Association, which later became known as the Royalton Township Chamber of Commerce. McCombs was only mayor for six months; Harry Dixon became the next mayor in 1928. (Courtesy of North Royalton Historical Society.)

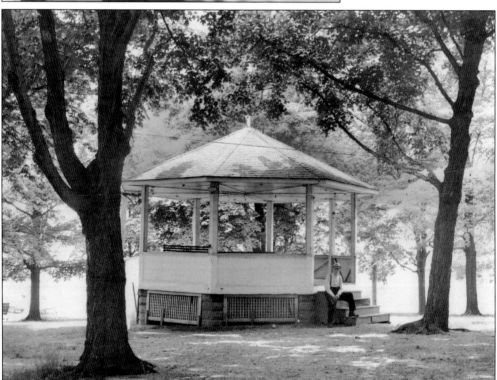

NORTH ROYALTON BANDSTAND. Sitting on the bandstand in 1957 is 86-year-old George Pennycook. Some records show that the bandstand was built around 1913. Bands used to play here during the Harvest Picnics, and residents and ministers also stood on the platform during events to give speeches. William McKinley was a speaker here the year he ran for president. People say that the first gazebo was built over the graves of settlers as a monument. (Courtesy of Cleveland Press Collection.)

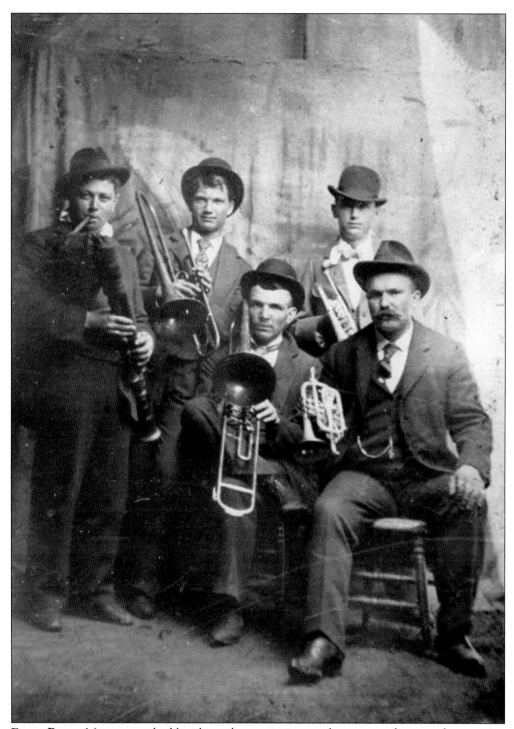

EARLY BAND. Many towns had bands to play at picnics or other events whenever the occasion presented itself. This band played at many town gatherings, most notably at the Harvest Picnics held each year. Members were usually offered a generous meal as their pay. (Courtesy of North Royalton Historical Society.)

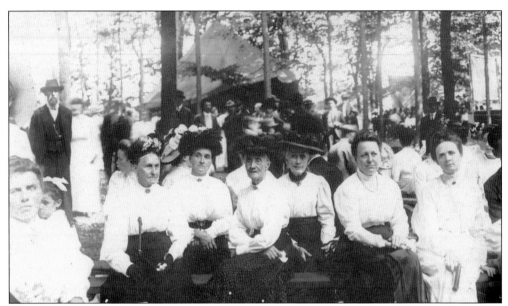

FARMER'S PICNIC. This postcard shows the Farmer's Picnic in Royalton. The last Farmer's Picnic in the woods was held on Bert Veber's land behind the Christian church on Royalton Road. After that, it was held at the village green. In the postcard with hats on are, from left to right, Mrs. Brown, Maggie Rust, Aunt Matt Chaffee, and Aunt Lottie. (Courtesy of North Royalton Historical Society.)

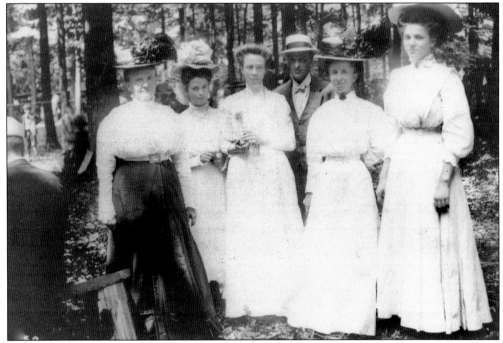

EARLY HARVEST PICNIC. This picnic has been traced back to around 1884, when a committee of citizens got together and planned various get-togethers held in the woods on farmers' land. From left to right are Mary Smith Veber, Avis Searles, Kitty Searles, Lester Edgerton, Rosa Haas, and unidentified. (Courtesy of North Royalton Historical Society.)

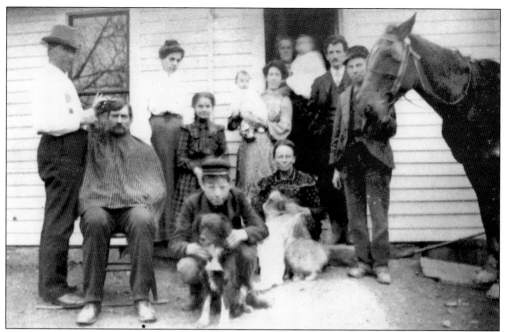

J.N. VEBER FAMILY. The Veber family and their horse and two dogs pose at their homestead. J.N. Veber was born in 1847 and served in the Civil War. In 1870, he married Mary Smith, and two years later he opened a store in the center of town. He was also township treasurer and a member of the Methodist church. (Courtesy of North Royalton Historical Society.)

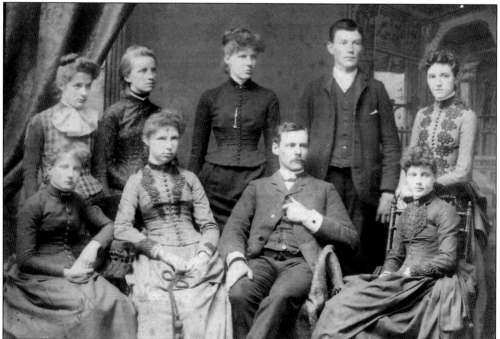

VEBER FAMILY. Daisy Veber (first row, far left), the daughter of J.N. Veber, poses with several other young people in the late 1800s. She later married Dr. Shildrick, and they lived in a house on Ridge Road. (Courtesy of North Royalton Historical Society.)

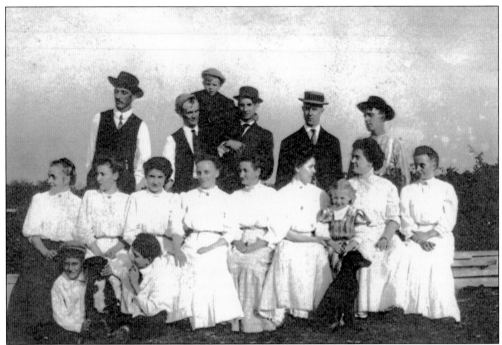

AKINS FAMILY. This is a large gathering of members of the Akins family, who are posing for a photograph. Henry Akins and his wife, Mercy, raised nine children. He had a great interest in local politics and public affairs. Henry died in 1877, but most of his family stayed in Royalton, and the Akins name came to be well known around town. (Courtesy of North Royalton Historical Society.)

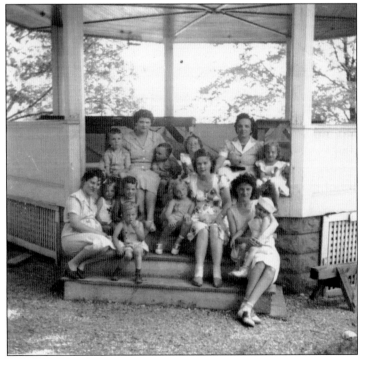

AKINS FAMILY REUNION. Mothers and children of the Akins family pose here in June 1945 at a reunion at the village green. Pictured are, from left to right, (first row) Edna Geiss Hall, Gail Hall, Ken Hall, Gary Hall, Margaret Ann Schaefer, Winifred Akins Schaefer, Ann Hall, and Allen Hall; (second row) Richard Howe, Lucielle Veber, Bobby Howe, Dolores Veber, Evelyn Veber, and Jane Veber. (Courtesy of Gail Holzman.)

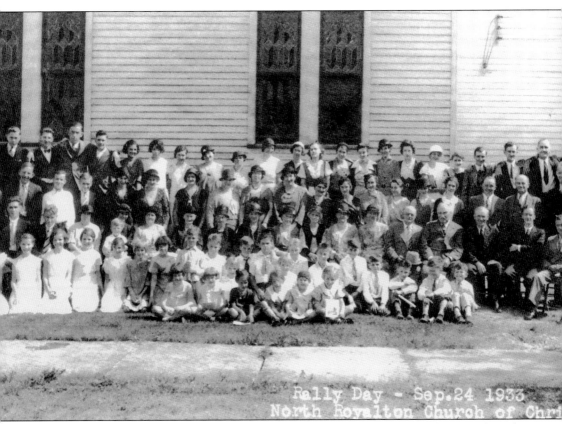

Rally Day - Sep. 24 1933
North Royalton Church of Chri

NORTH ROYALTON CHRISTIAN CHURCH. The members of the Disciple Church posing here for photograph in September 1933 include, from left to right, (first row) Betty Jane Hamblin, Virginia Loesch, three unidentified girls, and Carol Ellis; (directly behind the first row) Marjorie Geiss Cash and Marion Geiss Huntington; (second row) Eloise Geiss O'Donnell, Louella Iglehart, Wanda Widlock, Edna Geiss Hall, June Goodman, Noreen Gaffney, Jean Loesch, Jack Barrick, Ray Goodman, George Akins, Jack Zajicek, Bingham Reeder, Robert Zabor, Richard Lohman, David Lohman, Jack Reidenbach, George Reidenbach, and Steve Widlock; (third row) Joe Lohman, Allen Oblander, Avis Bassett, Sylvia Heegs (holding Frank Heegs), Mrs. Iglehart, Margaret Geiss, Mrs. Wilcox, Mrs. Hamblin, Kitty Searles, Rose Haas, Mrs. Wiltshire, Lucy Bowman, Mr. Porter, Mr. Dolezol, Mr. Iglehart, Rev. Oliver Cowles, and Glenn Dailey; (fourth row) Edward Bassett, Gilbert Allen, William Reidenbach, Edward Akins, Clara Hamblin, Emma Zabor, unidentified, Bernice Wiltshire, Lottie Stigler, Rose Dolezol, Etta Akins, Dorothy Cerny Spelman, Clarice Cerny Monhart, unidentified, Gertrude Ruff, Evelyn Wickman, Henry Loesch, Edward Cerny, and Fred Heege; (fifth row) Dwight Hamblin, Carl Wickman, Clifford Allen, Leonard ?, Lucille Zajicek, Jean Lohman, Naomi Bailey, Hazel Geiss, Clara Geiss, Eva Loesch, Winifred Akins Shaeffer, Ruth Annis, Mrs. Cowles, Thelma Akins Zizka, Mable Pichota, Virginia Osterland, Viola Iglehart, Edward Geiss, Ernest Geiss, Jack Zabor, and Harold Hamblin. (Courtesy of Gail Holzman.)

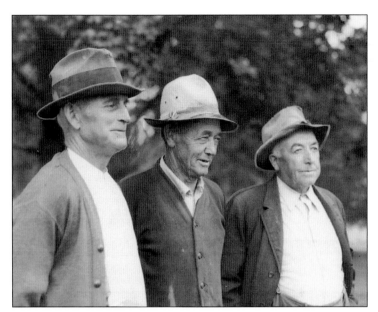

HOMECOMING, 1931. From left to right, William Jacque, Elmer Ellsworth, and F.W. Ellsworth pose at the 1931 homecoming. Homecoming, previously called the Harvest Picnic, was a time for farmers and friends to gather and spend the day celebrating the harvest season. The picnic was usually held in woods or groves owned by a farmer. (Courtesy of Cleveland Press Collection.)

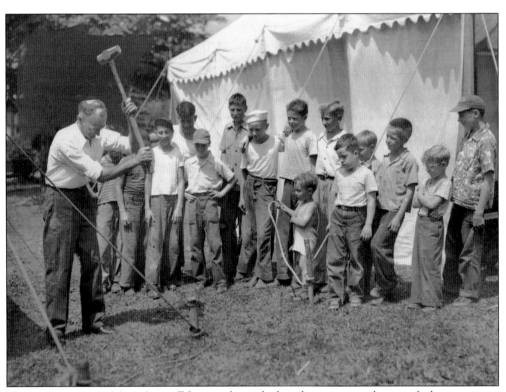

HOMECOMING, 1947. Mayor Lester Edgerton shows the boys how to set up the tents for homecoming. In the 1930s and 1940s, the grand prize at Homecoming was usually a Ford or Chevrolet car. The highlights of the day were the many different competitions, including a cake-baking contest with prizes for the winner. (Courtesy of Cleveland Press Collection.)

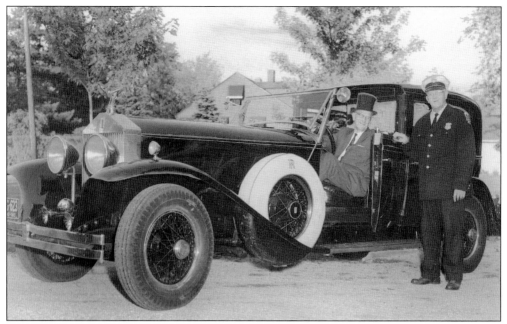

EARLY CARS. Mayor Lester Edgerton sits in a 1929 Rolls Royce owned by local resident Dan Fowler with retired police chief Clayton Akins standing to the right in this 1963 photograph. Before cars became the major mode of transportation, many settlers traveled by wagon, horseback, or on foot. (Courtesy of Cleveland Press Collection.)

NORTH ROYALTON RED CROSS, 1941. The hardworking ladies of the Red Cross during the World War II years included, from left to right, Mrs. Frank Owen, Mrs. E.C. Ellsworth, Mrs. F.J. Young, Mrs. Charles J. Novak, Mrs. E.C. Osterland, Betty Owen, Harriet Stone, Evelyn Lutz, Hanna Wilcox, Mrs. George Lewis, and Mrs. N.O. Dunham. The International Committee of the Red Cross dates back to 1863. (Courtesy of Cleveland Press Collection.)

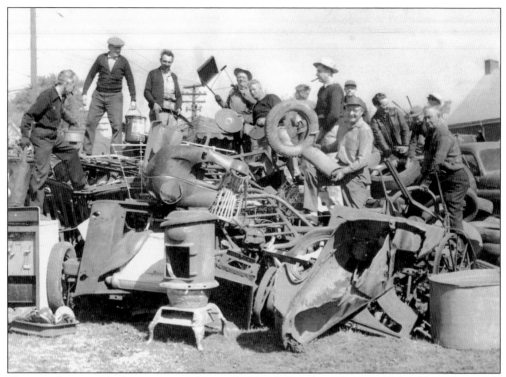

KIWANIS CLUB, 1951. In its inaugural year, the North Royalton Kiwanis Club adds to their junk heap on the village green. The club was hoping to raise $1,000 to buy equipment for the machine shop and home economics classes as well as the band for the new high school on Ridge Road. (Courtesy of Cleveland Press Collection.)

SCENIC SHOT. The town hall is decorated for Christmas in 1963. The first town hall was built by Knight Sprague. In 1870, a new town hall made of brick was constructed, which began being used simultaneously as a high school in 1904. In 1937, it was torn down to make room for this town hall. (Courtesy of Cleveland Press Collection.)

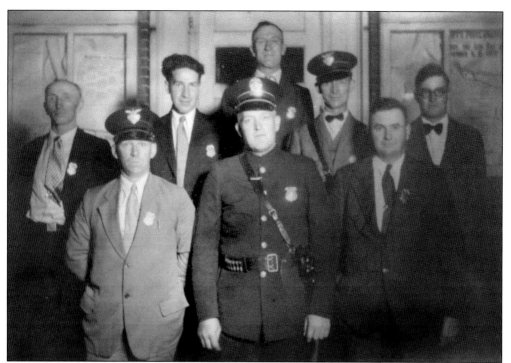

POLICE DEPARTMENT, C. 1925. In the mid-1920s, the police department included, from left to right, (first row) Ralph Wiltshire, Chief Clayton Akins, and George Haag; (second row) unidentified, Edward Gedeon, Pete Mader, and Kirk Saunders; (third row) Joe Bena. Before the police department was established, constables were appointed to keep peace in the area. (Courtesy of North Royalton Historical Society.)

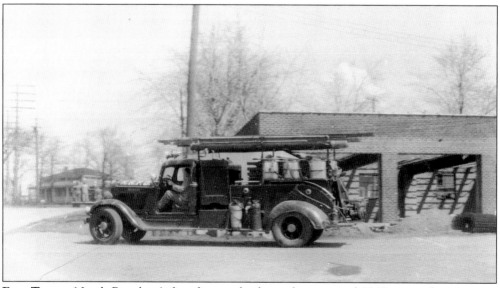

FIRE TRUCK. North Royalton's first fire truck, shown here around 1940, turns the corner at Bennett and Ridge Roads. The first fire committee was formed in 1927, made up of citizens and public officials. Elmer Breyley was the first fire chief and Robert Breyley followed him. (Courtesy of North Royalton Historical Society.)

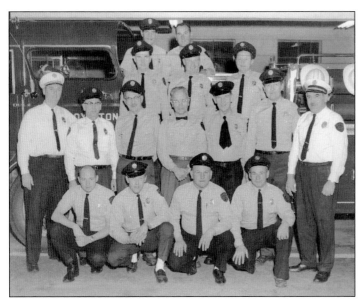

NORTH ROYALTON FIREMEN. The 1951–1952 fire department included, from left to right, (first row) Jack Phiel, Tom Fashempour, John Ridler, and Frank Smandl; (second row) Chief Don Aitken, John Reed, Clarence ? , Clarence Gillian, Ed Kupchick, Howard Grosser, and William Krivos; (third row) Don Kupchick, Joe Ohman, and George Cisar; (fourth row) Mario DeBlazey and Lloyd Clark. (Courtesy of the Mayer family.)

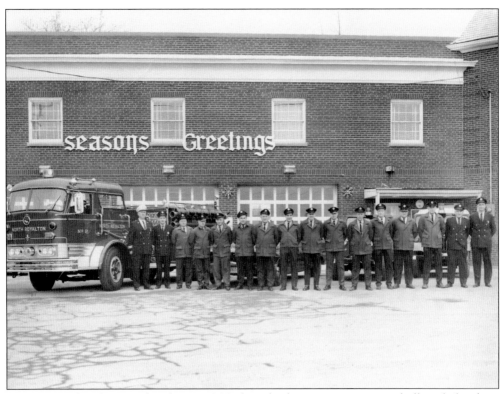

FIREHOUSE. This photograph, taken in 1966 when the fire station was at city hall, includes, from left to right, Chief Don Aitken, Lloyd Leimbach, George Cisar Sr., Joe Ohman, Ray Uffman, Lloyd Clark, John Ridler, Mario DeBlazey, Roy Lewis, Jack Phiel, Tom Fashempour, Ron Flowers, Ed McHugh, Howard Grosser, William Krivos, and Elwood Mayer. (Courtesy of the Mayer family.)

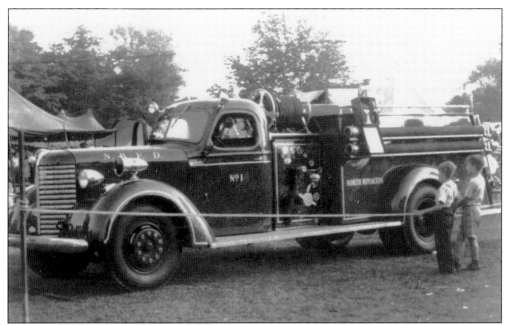

FIRE TRUCK. The new Buffalo fire truck is being shown off at the 1947 Homecoming. Early firemen had to know how to start their pumper blindfolded in case the fire did not give them a good amount of light when they got to the scene. In 1943, volunteer firemen were paid $1 per fire; by 1964, the city authorized a full-time fire department consisting of a fire chief and four firemen. (Courtesy of the Mayer family.)

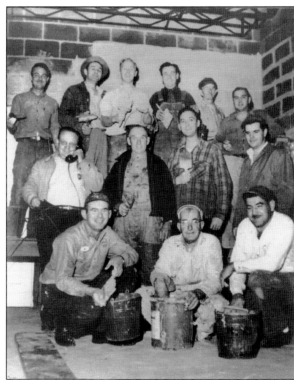

FIRE STATION. Firefighters posing while painting the fire station in the basement of city hall include, from left to right, (first row) Art Johnson, Ralph Wiltshire, Don Aitken, Don Kupchick, Chief Robert Breyley, Ray Scanlon, and William Krivos; (second row) Herman Schuster, William Krivos, Gene Neal, Frank Smandl, L.C. Pay, and Lloyd Clark. (Courtesy of the Mayer family.)

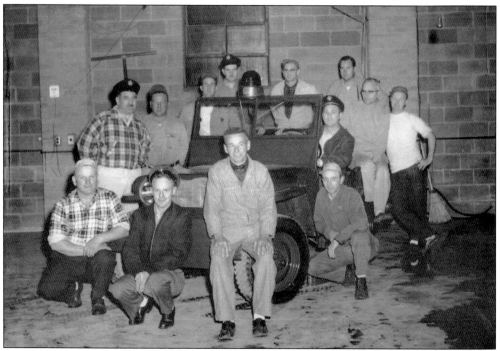

FIRE JEEP. Firemen posing in 1942 around this fire jeep donated to the city are, from left to right, (first row) John Ridler, Joe Ohman, Frank Smandl, and Ray Uffman; (second row) William Krivos, ? Phillips, Elwood Mayer, Don Kupchick, John Reed, Lloyd Clark, Clarence Gillian, and Eugene Neal; Chief Don Aitken is seated in the jeep. (Courtesy of the Mayer family.)

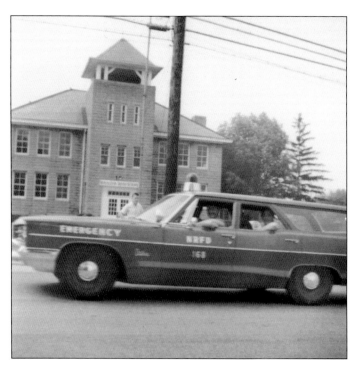

HOMECOMING PARADE. The old Royalton Road School is in the background in this photograph. The vehicle seen in front was used by the fire department for transportation around town. Before the fire department was established, fires were usually put out by neighbors in bucket brigades, where buckets of water were passed down from person to person until the fire was successfully put out. (Courtesy of the Mayer family.)

Two

SCHOOLS

Formal education in the township began as early as 1818 after the first township election. Until then, early settlers taught children the basics of reading, writing, and geography in their homes. Later, one-room schoolhouses were built, where all the children of various grade levels received an education. The first schoolhouse was made of logs. Pegs were inserted into the log walls and writing boards hung so that students could work on their studies. There were hardly any funds set aside for schools at the time, and classes were only held three months of the year.

The first school district formed in 1829. A year later, it was divided into four school districts, with schoolhouses located at almost every intersection. Later, there were as many as nine districts because the roads were sometimes in such bad condition it was difficult for children to get to and from school.

In 1907, Royalton Road School was built, ending the era of one-room classrooms. This new school had four classrooms, two on each floor. But because North Royalton was rapidly growing, the city eventually outgrew this school, and North Royalton High School was built in 1952. Albion, Valley Vista, and Royalview schools were built shortly after.

Today, North Royalton has multiple schools housing various grade levels and many award-winning academic programs, groups, and clubs.

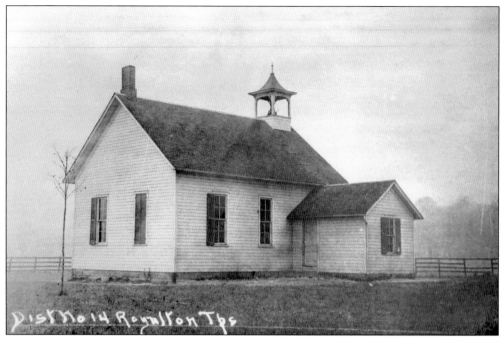

EARLY SCHOOLHOUSE. This image shows a one-room schoolhouse built on Edgerton Road in the mid-1800s. All of the children had to walk to school, and since the roads were so bad there were nine districts to accommodate all of the students. (Courtesy of North Royalton Historical Society.)

SCHOOLHOUSE. Shown here is the schoolhouse at Boston and Broadview Roads. During the early 1850s, teachers were paid $4 per month for the summer, $5 per month for the fall, and $8 per month in the winter; the only subjects taught were reading, writing, and geography. (Courtesy of North Royalton Historical Society.)

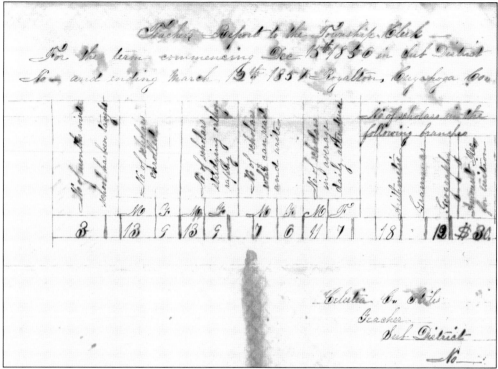

TEACHER'S REPORT. This is an early teacher's report from District School No. 14 in the 1856–1857 school year. If the teacher did not fill out this report, she or he was not paid for that term. Around 1857, the school year was divided into winter and summer terms. By that time, teachers made $10 per month in the summer and $16 per month in the winter. (Courtesy of North Royalton Historical Society.)

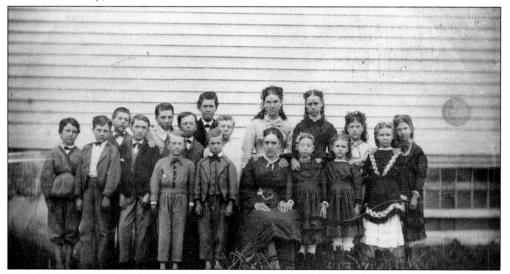

BANG'S CORNERS. This photograph was taken in the late 1800s at the Bang's Corners District School. During this time, the trustees wrote the first nine-month contract for a teacher, including wages of $30 per month. Around this time, the first cleaning person was also hired, earning $1.60 per month. (Courtesy of North Royalton Historical Society.)

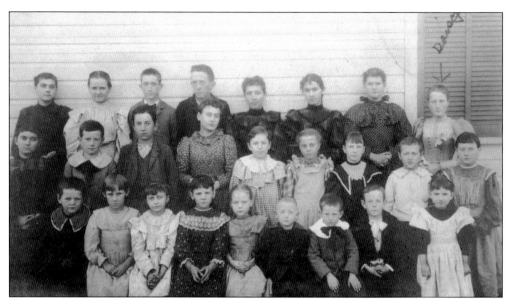

EARLY CLASS. Teacher Daisy Veber stands with the students of her schoolhouse, who were of various ages. Many of the early schools were heated by a wood stove, and one of the students was usually assigned to unlock the school each morning and get the stove started. Two children were often sent to a nearby neighbor for water, carrying it back in a pail suspended on a stick between them. (Courtesy of North Royalton Historical Society.)

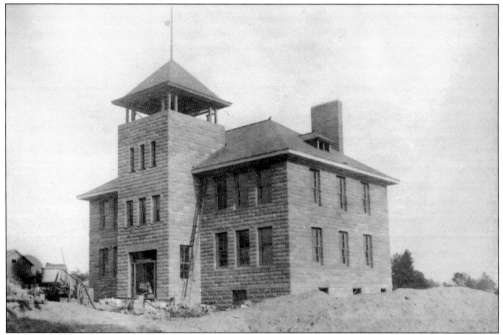

ROYALTON ROAD SCHOOL CONSTRUCTION. The Royalton Road School is seen here under construction in 1908. The school bell became a symbol of pride for the community. It was removed when the structure was torn down in 1972 and eventually placed in storage. In 2006, it was refurbished and dedicated as a remembrance to past, present, and future students. (Courtesy of North Royalton Historical Society.)

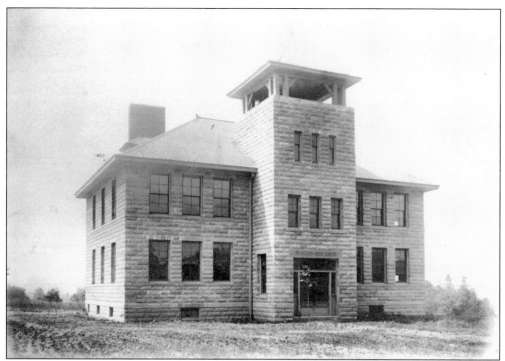

ROYALTON ROAD SCHOOL. The Royalton Road School was dedicated in 1908, with two first-floor classrooms and two second-floor classrooms. The center tower held the school bell as well as the principal's office. In 1914, fire escapes were installed. (Courtesy of North Royalton Historical Society.)

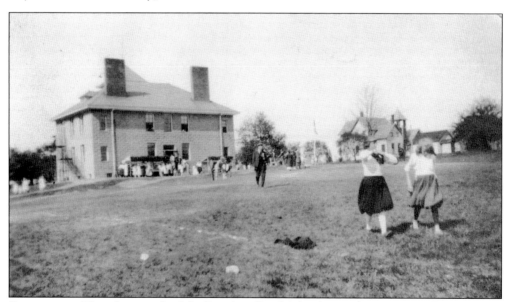

SCHOOLYARD. This photograph of the Royalton Road School was taken sometime between 1914 and 1923, when the school was added on to. The bell in the tower always rang at 9:00 a.m. to start the school day. In later years, it rang whenever a sports team won a game. (Courtesy of North Royalton Historical Society.)

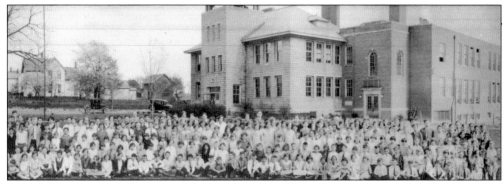

SCHOOL PHOTOGRAPH. Students of the Royalton Road School pose in front of the building that features an extension added to the back in 1923, which contained a gymnasium, more classrooms, a library, a stage, and a home economics lab. All of the children in North Royalton went to this school until 1951, when the new high school opened. This school closed its doors in 1970. (Courtesy of North Royalton Historical Society.)

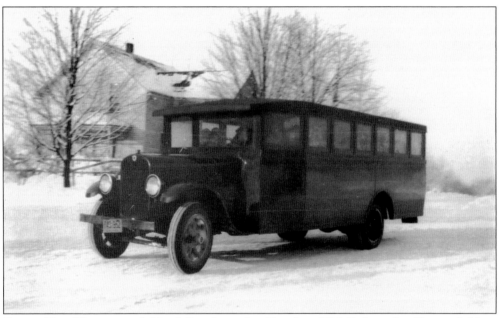

SCHOOL BUS. This is an early North Royalton school bus from 1915. Before school buses, children were often taken to school in "kid wagons" that benches on each side and two steps in the back. These wagons were usually pulled by teams of horses but were not covered, so in bad weather straw was placed on the floor and horse blankets were draped over the children's laps. (Courtesy of North Royalton Historical Society.)

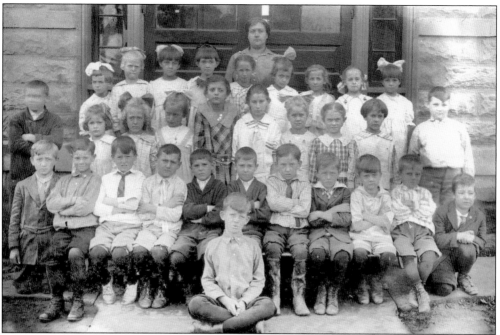

GRADES ONE THROUGH THREE. Miss Laura Evans poses with her students in the 1917–1918 school year, including, from left to right, (seated) ? Lahl; (first row) two unidentified boys, Paul Averill, three unidentified boys, Clifford Allen, Howard Carter, two unidentified boys, and Ralph Becker; (second row) an unidentified boy, two unidentified girls, Lola Allen, Eva Rennert, Lela Akins, Marie Becker, Margaret Pasek, ? Clark, and George Edgerton; (third row) unidentified, Eleanor Brand, Olive Allen, Mabel Meiche, Ruth Wagner, Clarice Cerny, Mildred Wagner, unidentified, and Robinette Allen. (Courtesy of North Royalton Historical Society.)

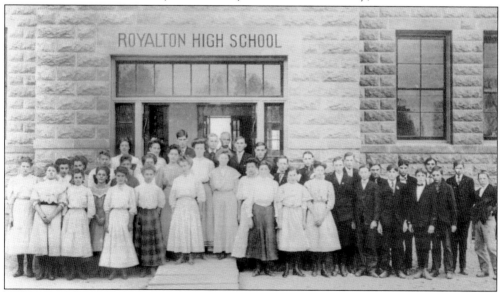

EARLY HIGH SCHOOL. This class photograph was taken in 1909, two years after the township's first graduating class of two students, Libbie Hejduk and Edgar Noble, who graduated from the old town hall in 1907. (Courtesy of North Royalton Historical Society.)

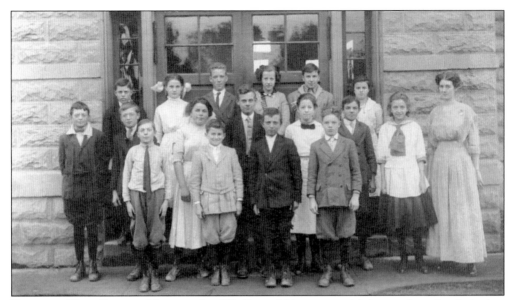

ROYALTON HIGH SCHOOL. Here, teacher Ella Porter Veber poses with her students for their class photograph. The first high school in the old town hall was a three-year course to graduate. Once this school was built, it allowed for more students, and in 1909 a record-breaking class of 11 graduated from the school. (Courtesy of North Royalton Historical Society.)

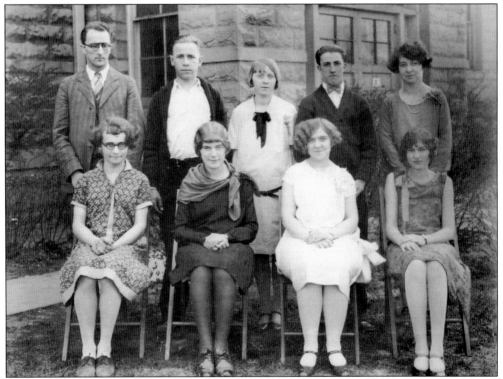

CLASS OF 1928. The graduating class of 1928 included, from left to right, (seated) Caroline Swantik, Dorothy Haas, Marguerite Behal, and Bernice Meyer; (standing) Leland Detrow, Frank Perzy, Margaret Pasek, Darwin Webster, and Lena Forster. (Courtesy of North Royalton Historical Society.)

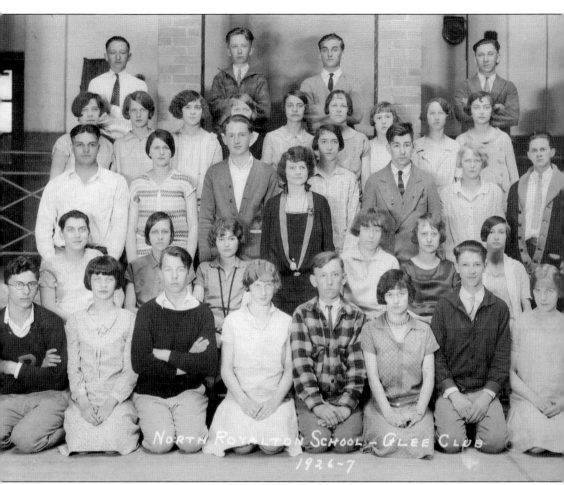

GLEE CLUB, 1926–1927. Posing for the Glee Club's yearly group photograph are, from left to right, (kneeling) Albert Tashjian, Dorothy Annis, John Higgs, Mildred Heyer, Clifford Allen, Evelyn Hudecek, Carl Wichman, and Dorothy Haas; (seated) Gertrude DeBow, Olive Allen, Bernice Meyer, Mildred Huelsman, Iola Allen, Emily Kontosh, and teacher Vivienne Ross; (third row) George Edgerton, Adelaide Volenik, Paul Averill, Mabel Meiche, Ralph Becker, Eleanor Brand, and Bill Chafer; (fourth row) Rose Praisler, Mary Pasek, Marguerite Behal, Margaret Pasek, Gladys Craddock, Amanda Rostel, Marguerite Ellsworth, Ruth Wagner, and Clarice Cerny; (fifth row) Carl Andrei, Harry Babroski, John Motznik, and Peter Kettering. (Courtesy of North Royalton Historical Society.)

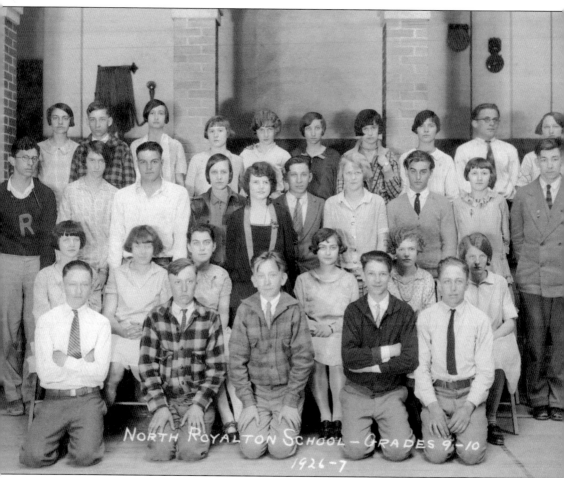

NORTH ROYALTON SCHOOL, 1926–1927. These Royalton Road School students are, from left to right, (kneeling) Carl Andrei, Clifford Allen, Harry Babroski, Carl Wichman, and Alfred Rostal; (seated) Dorothy Annis, Mildred Huelsman, Gertrude DeBow, Clarice Cerny, Mildred Rain, and Mary Pasek; (third row) Albert Tashjian, Mabel Meiche, George Edgerton, Olive Allen, teacher Vivian Ross, Peter Kettering, Eleanor Brand, John Motznik, Helen Pasek, and Ralph Becker; (fourth row) Gladys Craddocks, ? Praisler, Emily Kontosh, Marguerite Ellsworth, Mildred Heyer, Mildred Wagner, Evelyn Hudecek, Helen Steranke, unidentified, and Ruth Wagner. (Courtesy of North Royalton Historical Society.)

CLASS OF 1931. The 13-member graduating class of 1931 included, from left to right, (first row) Stanley Pichotte, Elmer Zabor, Helen Benjamin, Evelyn Volenik, Raymond Hudecek, and Don Vacha; (second row) William Hejduk and Dawson Kinch; (third row) Ralph Pay, class advisor Mr. Johnston, Joseph Volenik, Eunice Hanson, Robinette Allen, and John Weisz. (Courtesy of North Royalton Historical Society.)

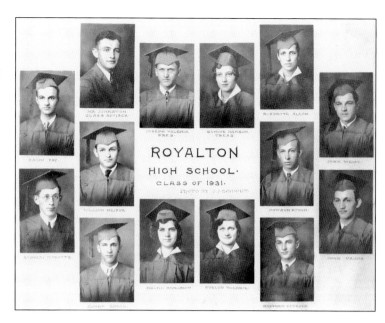

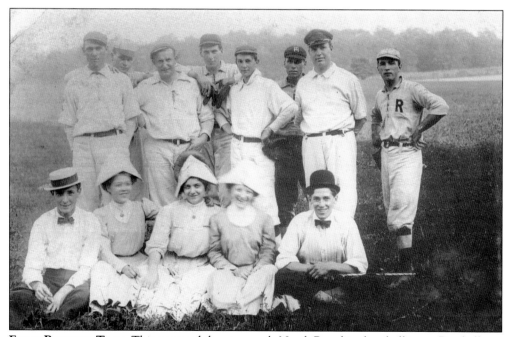

EARLY BASEBALL TEAM. This postcard shows an early North Royalton baseball team. Baseball was the first organized sport in the township in the early 1920s, when games were played by farmers and shopkeepers who formed two teams, West Royalton and North Royalton. The teams usually played on Saturday afternoons behind the Methodist church in a field owned by Bert Veber. (Courtesy of North Royalton Historical Society.)

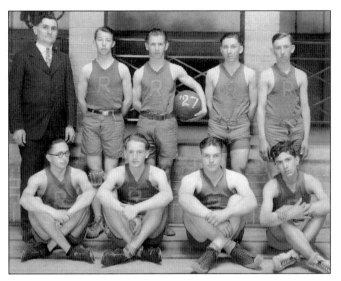

NORTH ROYALTON BASKETBALL. The 1927 North Royalton basketball team included, from left to right, (seated) Milan Kontosh, Paul Averill, George Edgerton, and Albert Tashjian; (standing) coach and superintendent Paul Roberts, John Higgs, Edmund Wagner, Peter Kettering, and Clifford Allen. Games were played in the school's gymnasium, which did not have bleachers to sit on, making them standing-room-only events. (Courtesy of North Royalton Historical Society.)

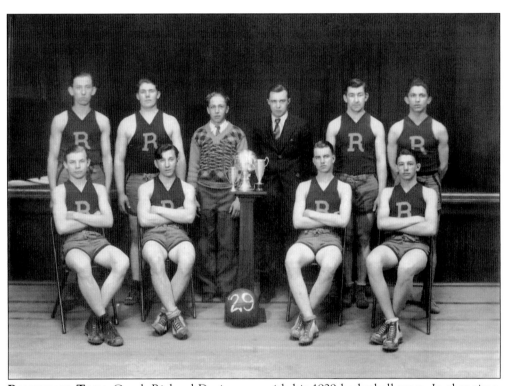

BASKETBALL TEAM. Coach Richard Davis poses with his 1929 basketball team. In that time, basketballs were heavy and hard because they were made of thick leather. After heavy use, they would eventually lose their shape, so players named them "pumpkins." (Courtesy of North Royalton Historical Society.)

BASKETBALL PLAYERS. The 1950 North Royalton basketball team included, from left to right, (first row) Dick Fowler, Chuck Hunter, and Eddie Ray; (second row) Al Caton, Bark Logan, and Jim Drdek; (third row) Don Slapak, Jerry Gunnerson, Joe Kmitt, and coach Harold Conrad. (Courtesy of Cleveland Press Collection.)

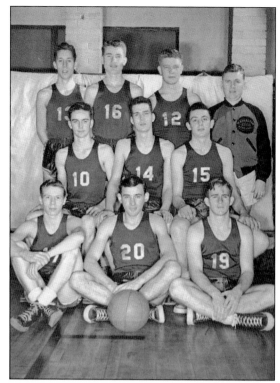

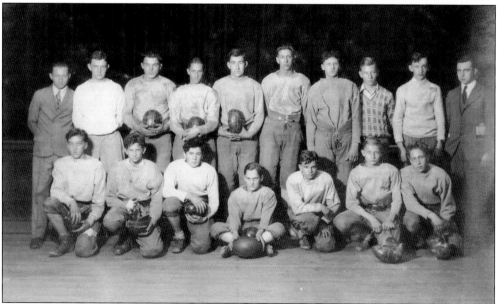

FOOTBALL TEAM, 1929–1930. North Royalton High School's first football team, seen here, practiced and played in Bert Veber's cow pasture across from the school. The team included, from left to right, (first row) Freddie Brumbaug, Bob Sliva, Marty "Sleepy" Wellman, Bud Zabor, Joe Ondercik, Gordon "Wrecks" Mader, and Al Rostal; (second row) coach "Punk" Johnston, John Wiese, Elmer Zabor, Ralph Becker, Melvin Hauser, Joe Volenick, Dawson Kinch, John Vacha, Rich Davis, and an unidentified player. (Courtesy of North Royalton Historical Society.)

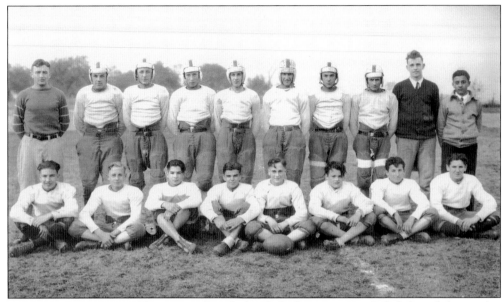

FOOTBALL TEAM, 1930. This team, identified only by last name, included, from left to right, (first row) Dukeshire, Mader, Debow, Ondercik, Zabor, Black, Burda, and Wellman; (second row) Johnston, Werig, Cerny, Kenich, Schoeff, Zabor, Breyley, Sliva, Bummey, and Kotora. Admission to football games was 25¢ at this time. A few years later, in 1934, the Golden Shoe tradition was started between the North Royalton and Brecksville schools. (Courtesy of North Royalton Historical Society.)

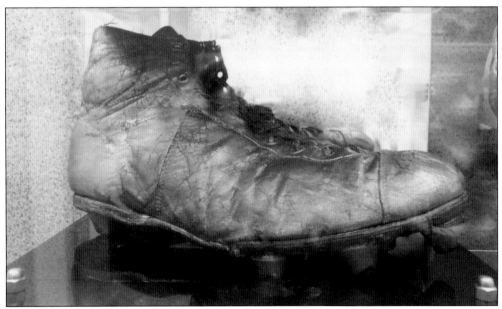

THE GOLDEN SHOE. The tradition of the Golden Shoe started in 1934 when a North Royalton football player named John Weisman left his shoe behind in Brecksville's locker room. This shoe was painted gold to resemble a trophy and became a symbol of the rivalry between North Royalton and Brecksville that continues to this day. (Courtesy of Susan Eid.)

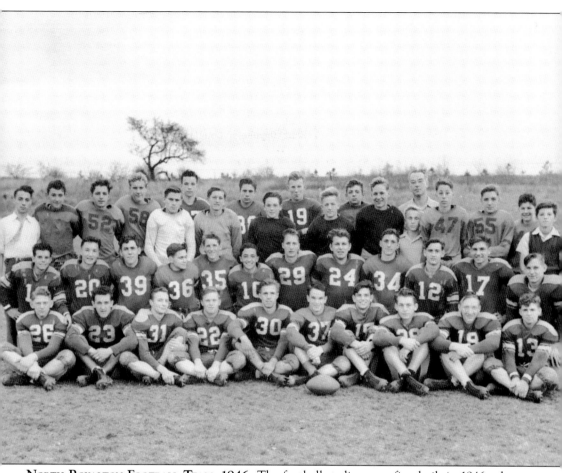

NORTH ROYALTON FOOTBALL TEAM, 1946. The football stadium was first built in 1946, when the team name was changed from the Ramblers to the Bears. The team included, from left to right, (first row) Gene Acker, John Jogan, Norm Schuster, Hank Cartwright, Dick Greywitt, Bill Brady, Joe Scholtz, Dwight Zimmerman, Dick Craddock, and Bill Zimlich; (second row) Dick Maher, Ken Fieldhouse, Ray Grumbling, Russ Saunders, Bill Hanze, Jack Horky, Bob Greywitt, Ted Novak, Joe Loeser, Ray Scholtz, Walt Zimlich, and Paul Schmiel; (third row) Eddie Olson, Chuck Hunter, Norm Hack, Bob Shankland, Earl Klunzinger, Stan Ryba, Gil Fulton, Stan Kmitt, Ken Hagedorn, John Halak, Don Slapak, George Schmiel, Bill Basford, and Don Bergstresser; (fourth row) Ty Chappelle, Wayne Gerdon, Jim Vlasak, Jim Dredek, and coach William Donnet. (Courtesy of Cleveland Press Collection.)

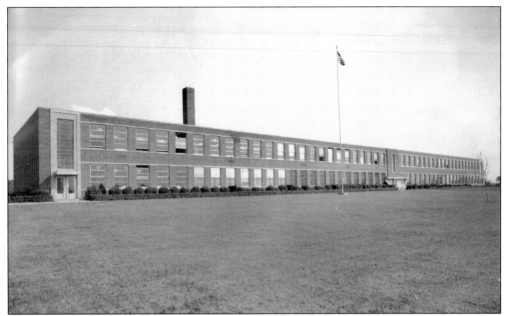

HIGH SCHOOL. The new high school was built on a 24-acre site on Ridge Road in 1951. A parade was held on the day everyone moved to the new school, with the band playing music as the students carried their school materials from the Royalton Road School to the new high school where a dedication ceremony was held. The left side of the high school was built in 1952, and the right side was added in 1954. (Courtesy of North Royalton Historical Society.)

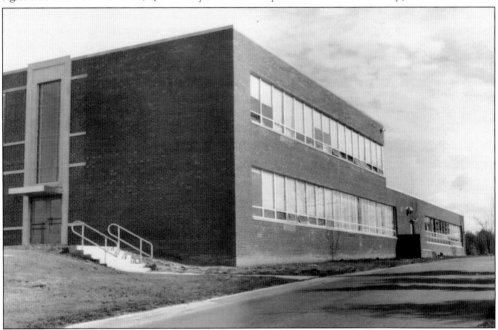

NORTH ROYALTON HIGH SCHOOL. The high school received another new addition in 1961; the cafeteria and kitchen were towards the back of the building. At the time, this school was called E.E. Root High School. In 1976, it was rededicated as North Royalton High School. (Courtesy of Cleveland Press Collection.)

GYMNASIUM. This 1956 view of the North Royalton High School gymnasium includes students Marion Law (left), age 17, and Lesley Law, age 9. In 1996, forty years after this photograph was taken, a new cafeteria, gym, and auditorium were dedicated. (Courtesy of Cleveland Press Collection.)

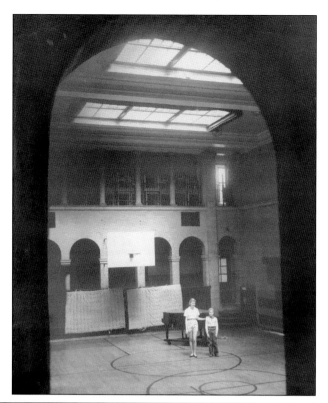

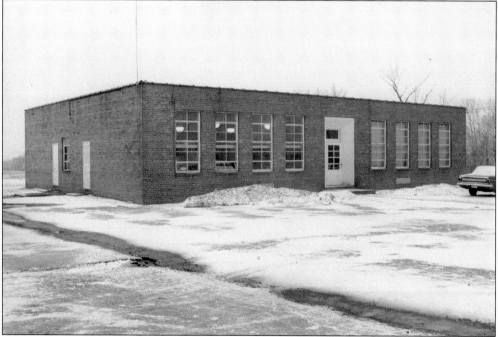

NORTH ROYALTON JUNIOR HIGH SCHOOL. This school was built in 1951 and is now referred to as the Annex. It currently houses administrative offices and has been added on to over the years. (Courtesy of Cleveland Press Collection.)

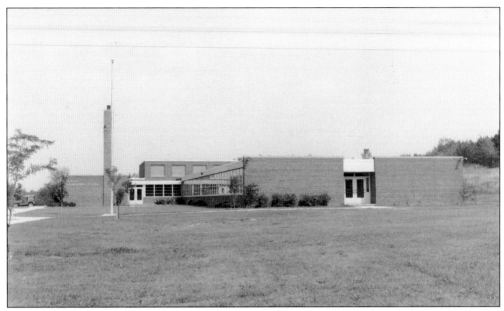

ALBION ELEMENTARY. When the high school opened up in 1952, North Royalton continued to grow. To help with overcrowding schools, the school board purchased additional land to build elementary schools on Albion Road, Wallings Road, and Lydle Road. (Courtesy of North Royalton Historical Society.)

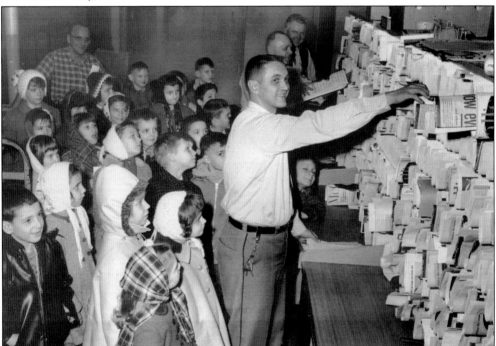

FIELD TRIP. Second-grade students from Albion Elementary School visit the North Royalton post office in 1962. They learned about postmen, who were also known as community helpers. The tour was arranged by superintendent Edward Jarmusik. (Courtesy of Cleveland Public Library Photograph Collection.)

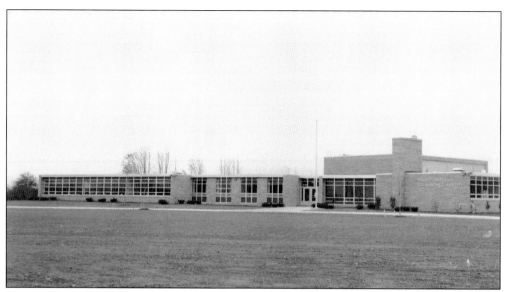

VALLEY VISTA. By 1956, growth in the schools was again becoming a problem, so Valley Vista was built in two separate stages: the first was completed in 1960 and consisted of six classrooms as well as central facilities, and the second stage was finished in 1962. The school is seen here after the addition. (Courtesy of North Royalton Historical Society.)

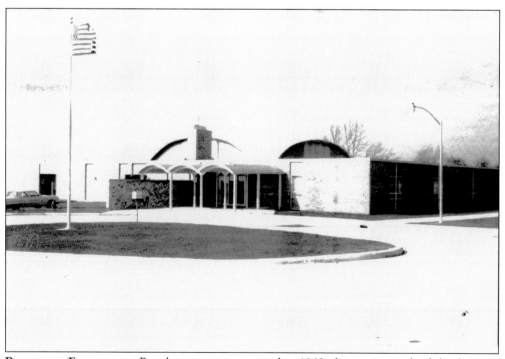

ROYALVIEW ELEMENTARY. Royalview was constructed in 1960, the same year the federal census certified the district as a city school district. In 1988, a new addition was added on to the school. (Courtesy of North Royalton Historical Society.)

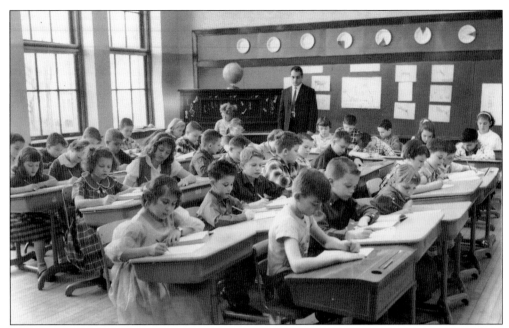

CLASSROOM. Crowded classrooms like this were common in 1960. Because of the overcrowding, sports teams and clubs often filled up quickly because there were so many students. In the 1960s, two new sports were made available: a wrestling team in 1963 and a golf team in 1966. (Courtesy of Cleveland Press Collection.)

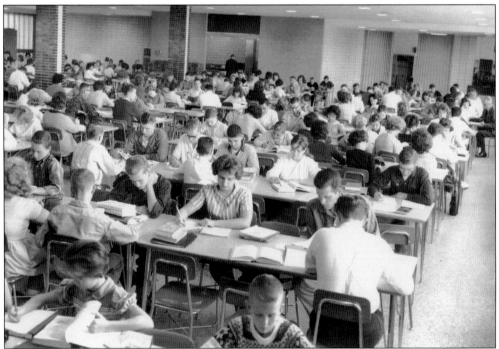

CAFETERIA. Because of overcrowding in the schools, many students had to study in the cafeteria, as seen here in 1961. In that era, the price for a school lunch was 35¢ for elementary students and 40¢ for junior and high school students. (Courtesy of Cleveland Press Collection.)

HOME ECONOMICS CLASS, 1954. In this home economics class at the high school on Ridge Road, Becky McCreery (left foreground) and Marge Edgerton (right foreground) learn the skills needed to provide for their future families. (Courtesy of Cleveland Press Collection.)

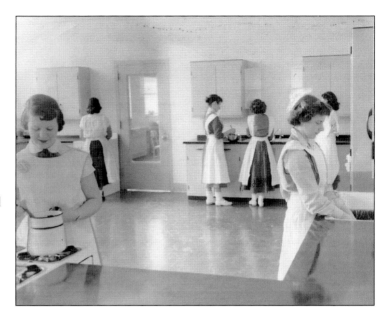

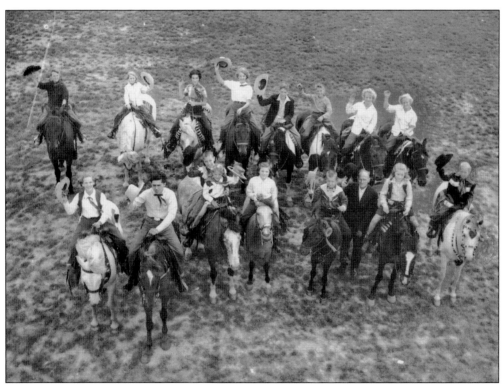

HORSE AND PONY CLUB. Members of the North Royalton Horse and Pony Club ride in August 1954. The first horse show for North Royalton was so successful that a horse club was formed. Mayor Lester Edgerton is shown in the lower right center on foot. Early settlers did not have time for clubs and groups, but as time went on and people became more settled, neighbors got together frequently to form clubs and organizations. (Courtesy of Cleveland Press Collection.)

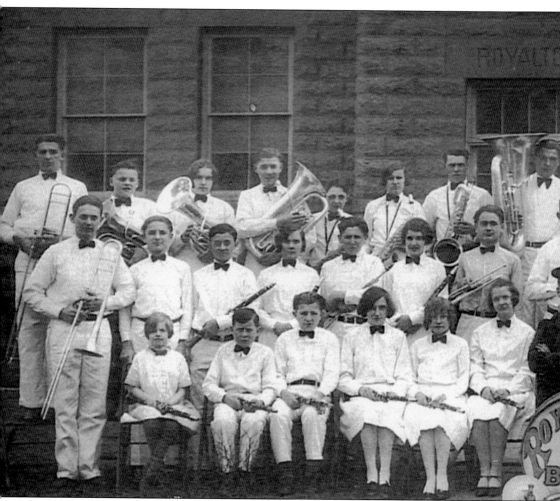

FIRST ROYALTON BAND. The band, seen here in 1930, was organized in April 1929 with around 33 members, composed mainly of high school students and some residents. John Grieves, the band director at Brecksville High School, directed the town band as well, leading evening

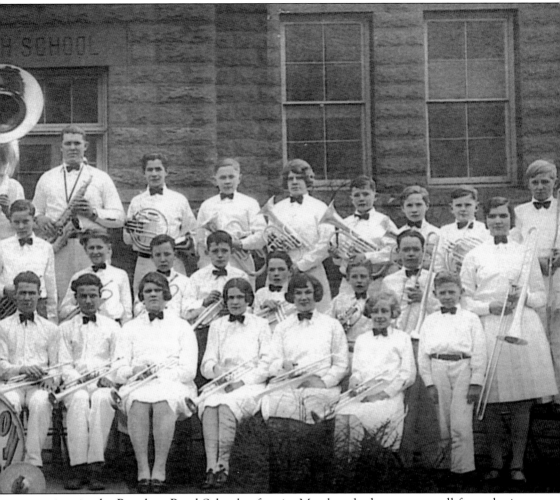

practices in the Royalton Road School cafeteria. Members had to pay a small fee to be in the band. Their first concert was on the bandstand at North Royalton's 1930 homecoming. (Courtesy of Marty Lydecker.)

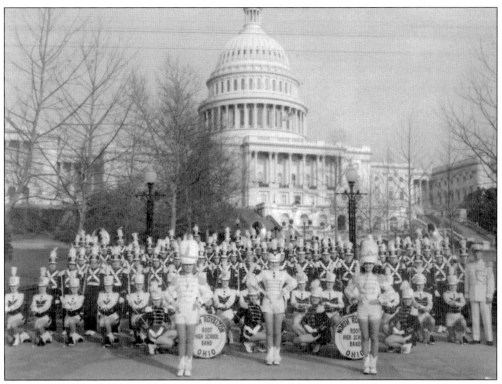

BAND IN WASHINGTON. In 1964, the North Royalton High School (NRHS) Band traveled to Washington, DC, and posed for this photograph in front of the Capitol building. In 1948, North Royalton's first marching band had 42 members and was directed by Harold Chidsey, who also wrote the words and music to the North Royalton alma mater. (Courtesy of Chuck Kirchner.)

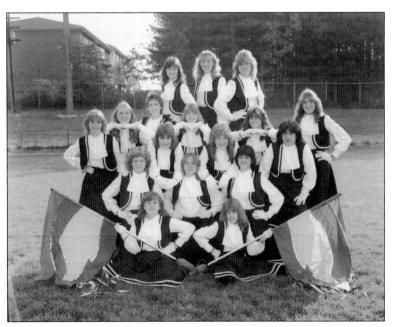

ROYALAIRES. The Royalaires flag team was added to the high school band in 1977 and consisted of 17 members the first year. Today, the teams usually have between 23 and 28 members. The Royalaires are currently under the direction of Brett Stalnaker. (Courtesy of North Royalton High School Band.)

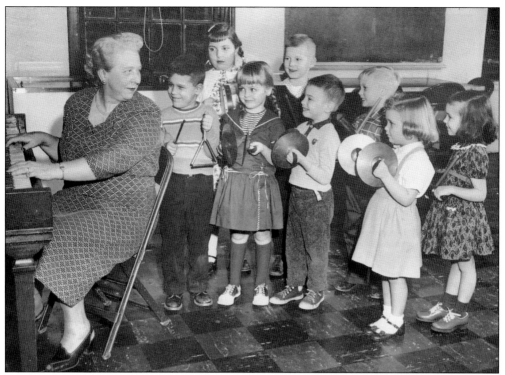

KINDERGARTEN MUSIC CLASS. Mrs. Lillian Veber plays the piano and leads her 1960 kindergarten class through a music lesson. The students are, from left to right, (first row) Kevin Barbeck, Susan Luterick, Ray Uffman Jr., and Nancy Campion; (second row) Cindy Mako, Bobby Shugert, Ronnie Vargo, and Robin Ebersole. (Courtesy of Cleveland Press Collection.)

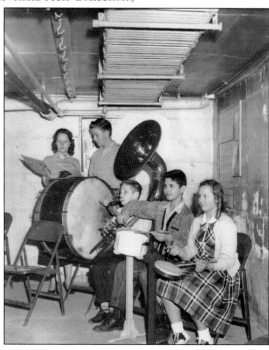

ELEMENTARY MUSIC CLASS. North Royalton Elementary School students experiment with different instruments in a music class being held in the basement. They are, from left to right, vocal music teacher Miss Norma Burst, Bob Kucharski, Richart Uhart, Frank Sandora, and Shirley Supek. In the early days, teachers were told to teach music on their own because the schools could not afford to hire a music teacher. (Courtesy of Cleveland Press Collection.)

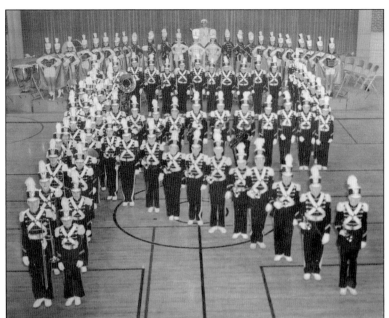

NRHS BAND. The 1960 NRHS Band, under the direction of Chris Carrino, forms an *R* for this photograph. In 1959, the band had a total of 68 members, but the next year there were 92 members, and by 1965 there were over 100 members. (Courtesy of North Royalton High School Band.)

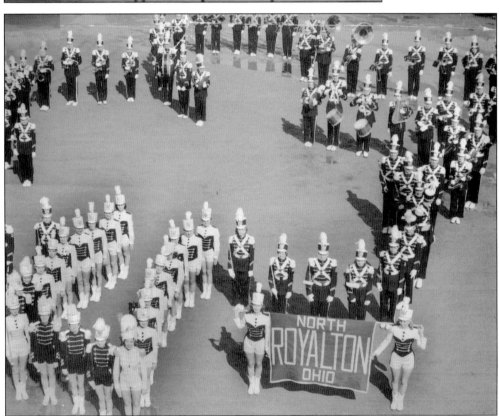

MARCHING BAND. The NRHS Band performs in the formation of a shamrock for good luck before members leave for New York in 1960. That year, they marched down Fifth Avenue in the St. Patrick's Day Parade. (Courtesy of Cleveland Press Collection.)

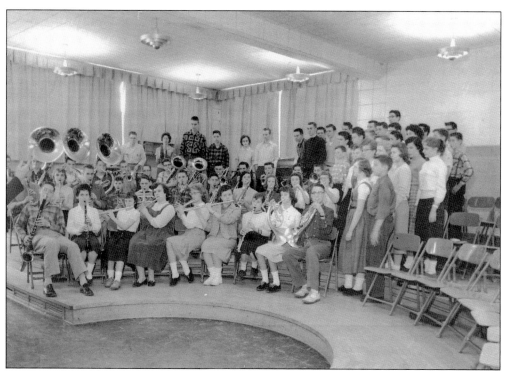

BAND PRACTICE. The high school band practices in the band room in 1958. The students who are standing had their instruments stolen when burglars broke into the school, getting away with more than $8,000 in instruments, tools, and office supplies. At the time of this photograph, the instruments had still not been found. (Courtesy of Cleveland Press Collection.)

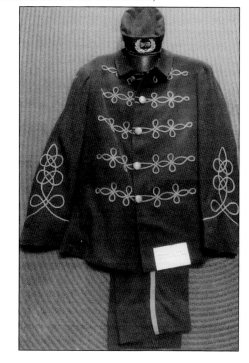

EARLY BAND UNIFORM. This 1892 band uniform was worn by a member of the Bennett's Corners Community Band. Many early bands played at local events for residents of the township as well as in neighboring communities. This uniform currently resides at the North Royalton Historical Society. (Courtesy of North Royalton Historical Society.)

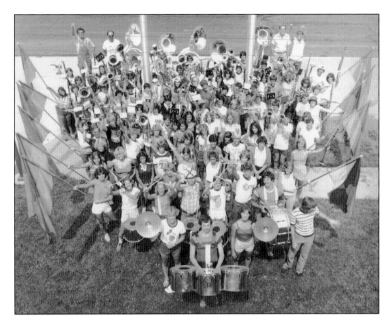

BAND POSES. This 1980s band poses for a photograph. In 1986, Marty Lydecker became the director, and the band qualified for state competition for the first time. In 1987, the marching band became the first to receive a superior rating in the Ohio Music Education Association (OMEA) state finals. (Courtesy of North Royalton High School Band.)

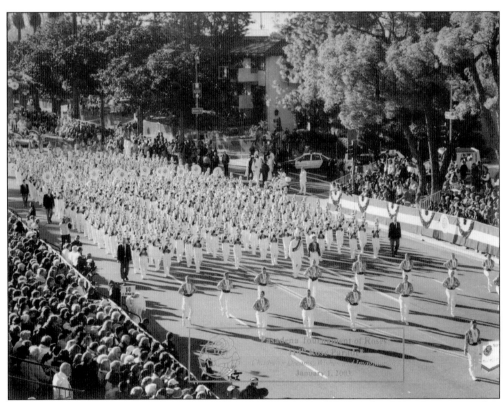

ROSE BOWL PARADE, 2003. The 330-member North Royalton High School Band was invited to perform in the 2003 Tournament of Roses Parade on New Year's Day in Pasadena, California, under the direction of Marty Lydecker. (Courtesy of North Royalton High School Band.)

Three
CHURCHES

North Royalton is home to a variety of churches dating back to the early 1800s. Early religious services were first held in members' homes, and circuit riders associated with the Methodist Episcopal Church visited homes to minister to settlers and organize congregations. As attendance at religious services grew, church members' houses were no longer big enough, and there was a need for church buildings that could also serve as gathering places for the community.

The first church in Royalton was the North Royalton Baptist Church, established in 1828 on the village green. After 100 years, a new building was put up farther down Royalton Road.

Early baptism ceremonies for some of the churches had to be performed in a natural reservoir, so they were held in a pond of clear water on the land of Thomas Coates. They were usually done in the wintertime, so the ice in the pond had to be broken and chipped. The newly baptized had to ride in a wagon back home with nothing on but a quilt or blanket over their clothes.

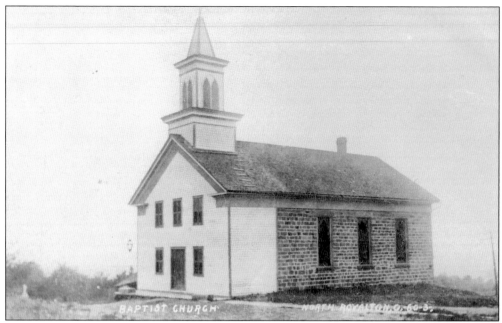

NORTH ROYALTON BAPTIST CHURCH. Established in 1828, this was the first church built in Royalton. Rev. Henry Hudson was the first pastor. The church was lit by kerosene lamps, with water coming from the town pump. This structure was located on the village green behind city hall. Services were held there until a new church was built in 1928. (Courtesy of North Royalton Historical Society.)

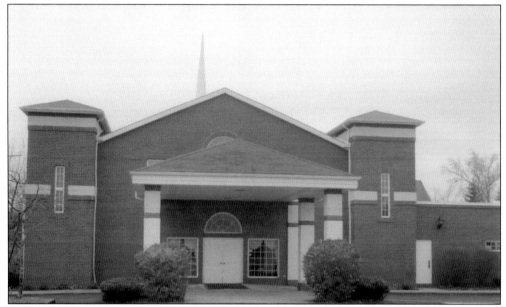

NORTH ROYALTON BAPTIST CHURCH. The original church building was found to be too expensive to repair, so the land was sold and new property at 6616 Royalton Road was bought in 1929. During construction, a penny was placed under the first stone laid and a prayer was offered. Services were conducted in the basement for eight years and then moved to Mount Royal Villa until the outer structure of the church was completed. (Courtesy of Susan Eid.)

NORTH ROYALTON CHRISTIAN CHURCH. Also known as The Disciple Church, this was the second church in Royalton, established in 1829 with 30 original members. In 1854, the original church was built in the front area of the North Royalton Cemetery. In 1896, another building was erected at the cemetery site, which eventually became the home of the Masonic Lodge. The church was closed only once due to a flu epidemic during World War I. In 1932, because of the widening of Royalton Road, the church was moved back from the road and a basement was added. (Courtesy of North Royalton Historical Society.)

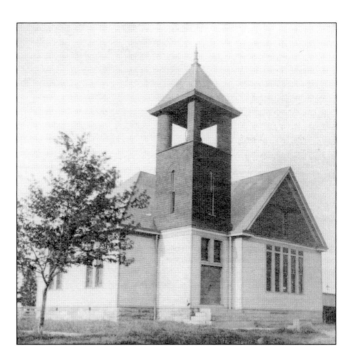

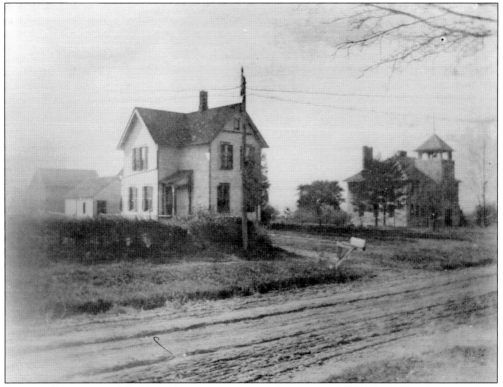

DISCIPLE PARSONAGE. The Disciple parsonage is seen here around 1930. In 1881, a donation from the will of a church member enabled the church to build this parsonage. This one-acre plot was purchased in 1885 for $100. (Courtesy of North Royalton Historical Society.)

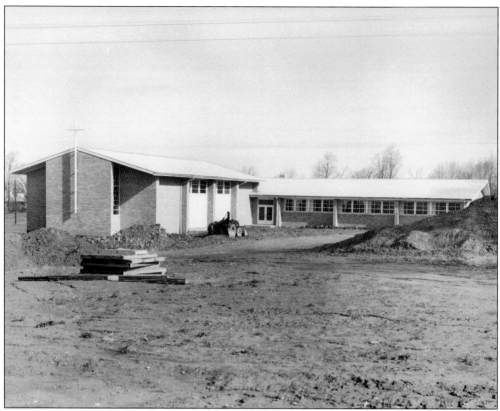

NEW BUILDING. The new North Royalton Christian Church at 5100 Royalton Road is seen here in 1963. This seven-acre site was purchased in 1960, and the building, which seated 250 people and had five classrooms, was dedicated on May 12, 1963. (Courtesy of Cleveland Press Collection.)

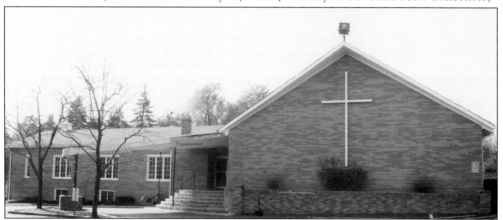

STATE ROAD COMMUNITY CHURCH OF THE NAZARENE. Located at 8600 State Road, this church, previously called Calvary Church of the Nazarene, was organized in January 1960. Services in the early building began in July 1960, which was constructed mainly by the members themselves, with some help from volunteers from other area churches. In November 1966, a new building was erected because the congregation was rapidly growing. The new building was dedicated in October 1967, and the church was renamed the State Road Community Church in 1980. (Courtesy of Adam Rhodes.)

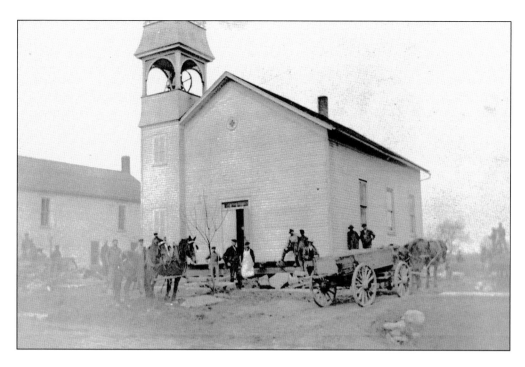

NORTH ROYALTON UNITED METHODIST CHURCH. Previously known as the Methodist Episcopal Church, the first church services were held in 1836 at various homes and at the Stewart schoolhouse at Edgerton and Akins Roads. The structure above was built between 1859 and 1860 on the corner of Wallings and Ridge Roads but was moved by teams of horses to a new site on Ridge Road in 1889. In 1923, renovations were added, including a basement, a new front door, and a large stained-glass window. After a new sanctuary was built in 1959, this church was used as a youth chapel and then leased to the Royalton Players in 1975. It was razed in 2000. The church is seen above around 1890 and below in its current state. (Above, courtesy of North Royalton Historical Society; below, North Royalton United Methodist Church.)

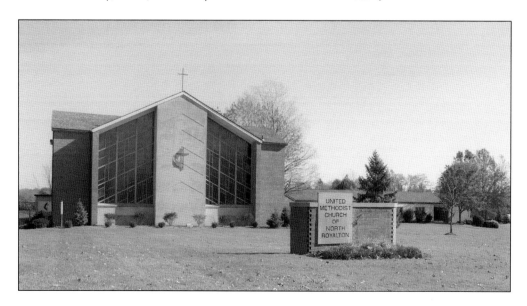

St. Albert the Great Church. This church was organized in 1959 by founding pastor Rev. Fr. A.J. Winters. Father Winters's priority was education, so in 1961 St. Albert's School was built with an enrollment of 360. Once the school was constructed, Father Winters focused on building a church, but before it was built families met for Mass at E.E. Root High School (now North Royalton High School). A basement church was constructed first until the church could afford to build the upper portion of the structure. In 1964, the basement church opened and served the parish for 17 years. The church building was finally completed in 1981, and an addition was added in 1996. (Courtesy of Susan Eid.)

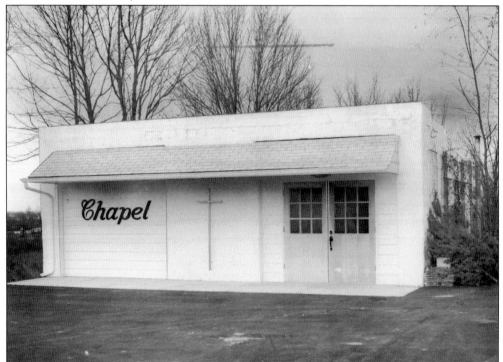

St. Albert's Chapel, 1959. This milk barn was converted into an adequate structure for chapel services for St. Albert's parish. It was located at 6745 Wallings Road, right where the upper parking lot is now. (Courtesy of Cleveland Public Library Photograph Collection/Robert J. Quinlan.)

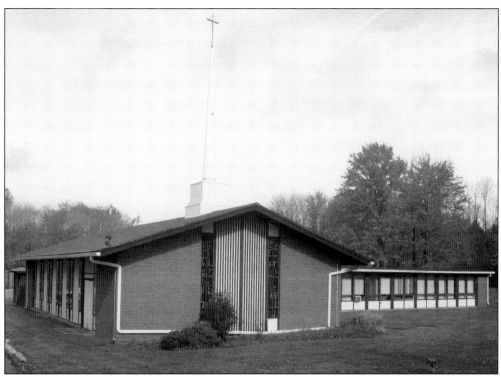

ABIDING SAVIOR LUTHERAN CHURCH. This church, at 4000 Wallings Road, was built on land bought in 1962 along with a nearby home to be used as a parsonage. Construction began in November 1962, and a month later the first service was held at Valley Vista Elementary School. In May 1963, the church was used for the first time, and on June 9 it was dedicated with Rev. Andrew Klopfer as the first pastor. Above is a current view of the church, and below is a 1963 interior view. (Above, courtesy of Susan Eid; below, Cleveland Public Library Photograph Collection.)

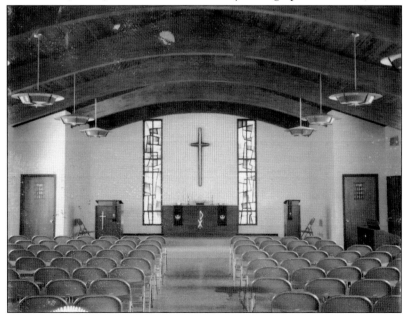

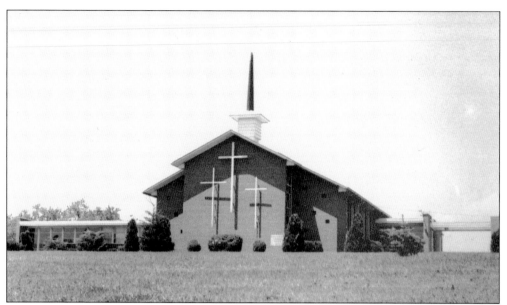

ROYAL REDEEMER LUTHERAN CHURCH. This church's first service was held at the town hall in 1956 with 23 members present. In March 1957, six acres of land around an old farmhouse was purchased at the corner of Abbey and Royalton Roads, and in 1958 the first service was held in the new church building. Above, the church is seen before 1987, and below is a photograph of the first service held in the old sanctuary on Christmas Day, 1958. (Courtesy of Royal Redeemer Lutheran Church.)

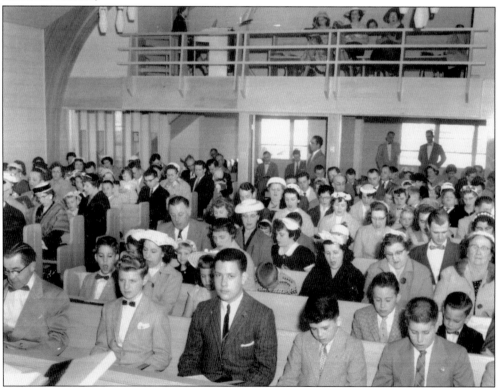

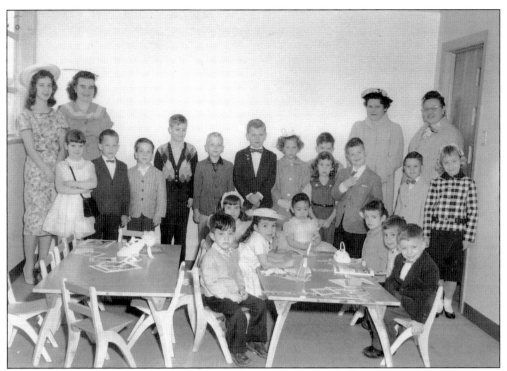

ROYAL REDEEMER SUNDAY SCHOOL. Seen here in 1958, these Sunday school primary- and nursery-grade students included Jerilyn Richwald, Elsie Virostek, Mark Luttner, Michael Richwald, ? Vargo, Carolyn Zazik, Elaine Finch, and Debbie Plawzan. (Courtesy of Royal Redeemer Lutheran Church.)

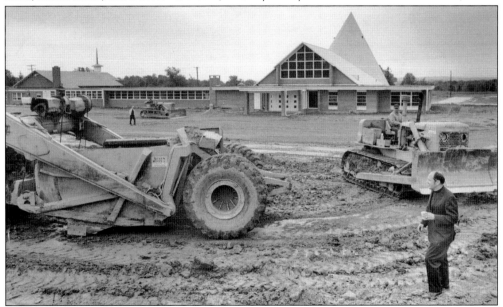

ROYAL REDEEMER EXPANDS. As the congregation continued to grow, a new sanctuary and an educational wing were built in 1969. Here, Pastor Marcis gets up close to the machines being used to grade and landscape around the new sanctuary in 1969. (Courtesy of Royal Redeemer Lutheran Church.)

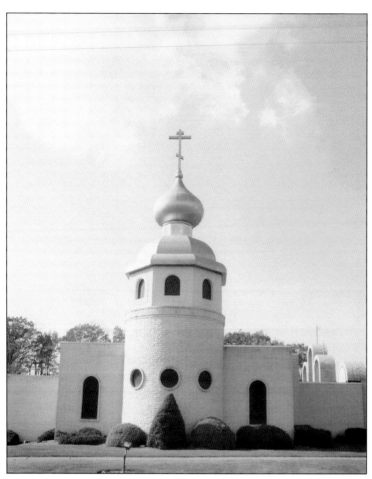

CHRIST THE SAVIOR AMERICAN ORTHODOX CHURCH. Located at 10000 State Road, this church was founded in 1964 and until 1974 met at a storefront in Parma. In 1976, it moved to a 22.9-acre property in North Royalton, and this building was erected. The construction of the church is seen below in 1976. (At left, courtesy of Adam Rhodes; below, Christ the Savior American Orthodox Church.)

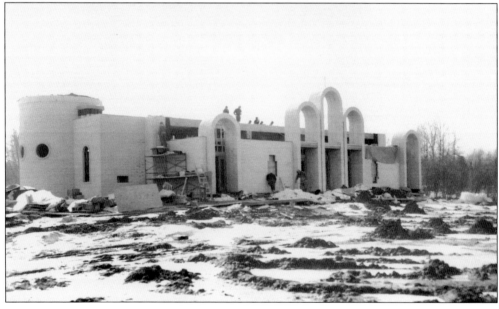

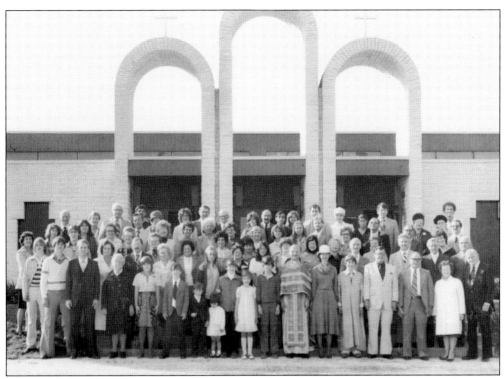

OUTSIDE OF THE NEW CHURCH. Above, the first congregation of Christ the Savior American Orthodox Church gathers in 1976. Below is the first Sunday school class, also in 1976. Organizations in the parish have included the Church School, the Ladies' Guild, the Men's Club, and the Youth Club. After the old church building was sold and before the new structure was built, the parish met at St. Paul Greek Orthodox Church for two years while awaiting the completion of their new church building. (Courtesy of Christ the Savior American Orthodox Church.)

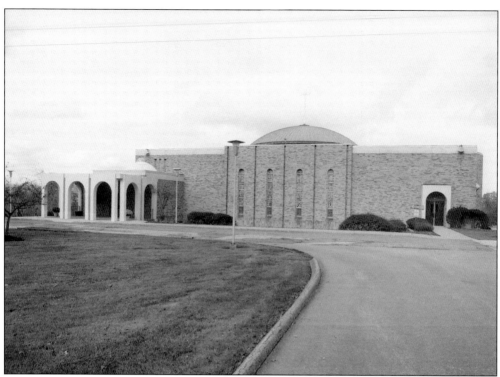

St. Paul Greek Orthodox Church. St. Paul's early services were held at Parma Memorial Hall. As the congregation grew, a new site was chosen and this church, at 4548 Wallings Road, had its first "Opening of the Doors" service in October 1970. Below is an interior view of the church. (Above, courtesy of Susan Eid; below, St. Paul Greek Orthodox Church.)

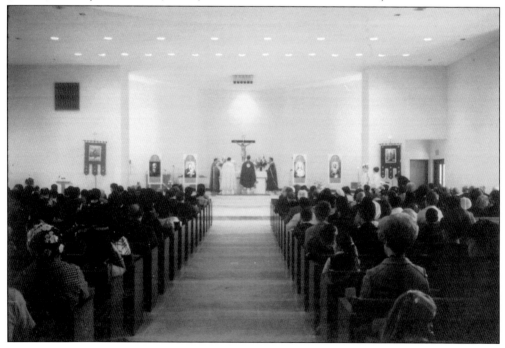

Four

ROADS AND BUSINESSES

As was typical in newly settled areas, there were no roads or paths in Royalton until 1818, so early settlers had to cut their way through to make their own path. People carried tools, such as axes, augers, and chains, with them so they could make their way to other areas to buy provisions.

As time went by, brush was cleared to make way for dirt roads, which were usually only wide enough for one wagon or carriage. Soon after, planks were laid across the roads, and road companies were formed, putting up tollgates and charging fees for use of the roads that were put towards keeping the roads in usable conditions. State and York Roads were both planked.

Iron bridges with planked floors were put up over areas that were likely to flood. In 1909, State Road became the first paved road in North Royalton. Royalton Road was not paved until 1924, but when it was the whole town took part in paving it.

One of the first businessmen in Royalton was Jonathan Bunker, who started a rope-making business in 1817. The first general store was opened by Royal Tyler in 1827. In 1830, Caleb Perry opened a blacksmith shop.

Royalton was at one time a prosperous dairy center because, unlike other townships, the soil in Royalton was too poor to raise crops. Soon after dairy farming developed, cheese factories appeared in the township, one at the corner of State and Royalton Roads and another near Bangs Corners. The cheese factories were eventually replaced by creameries.

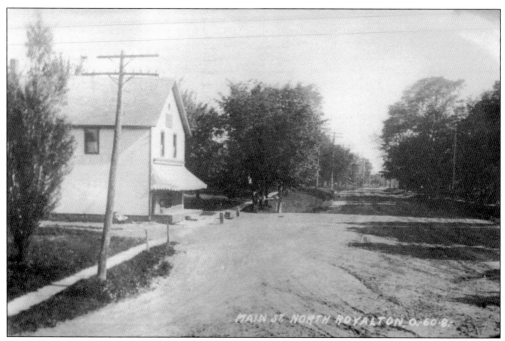

MAIN STREET. This postcard shows the main street, actually called Ridge Road. Photographers at the time called it Main Street because it had the highest concentration of businesses and homes. The building to the left is J.N. Veber's store, across from the Methodist church at the corner of Ridge and Bennett Roads. (Courtesy of North Royalton Historical Society.)

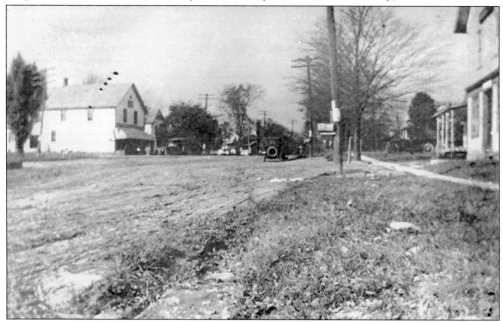

ROYALTON CENTER. J.N. Veber's store is again seen on the left here. Before Veber took it over in 1872, it was the Coates store. The first telephone in Royalton was in Veber's store, and service was from 7:00 a.m. to 9:00 p.m., after which only emergencies were allowed through the lines. (Courtesy of North Royalton Historical Society.)

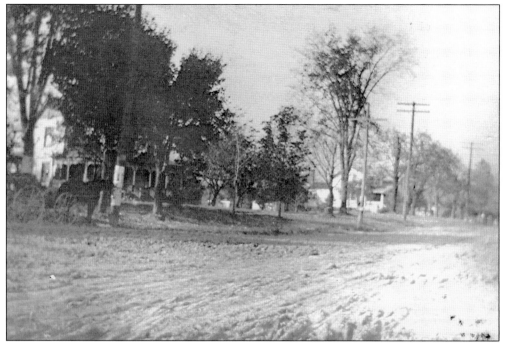

CENTER OF TOWN. In 1820, there were three main roads in Royalton. Royalton Road was called the "East-West Road" because it went through the center of the township, Ridge Road was called "Center Road" and was the main route leading to Cleveland, and State Road (Route 94) ran parallel to Ridge Road. (Courtesy of North Royalton Historical Society.)

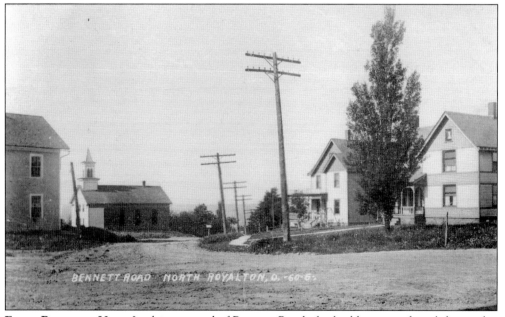

EARLY POSTCARD VIEW. In this postcard of Bennett Road, the buildings are, from left to right, the town hall, the Baptist church, the Fairview Hotel, and the Veber house. Bennett Road was finished in 1823 and was originally called Augle Road, later named after Moses O. Bennett of Strongsville. (Courtesy of the Mayer family.)

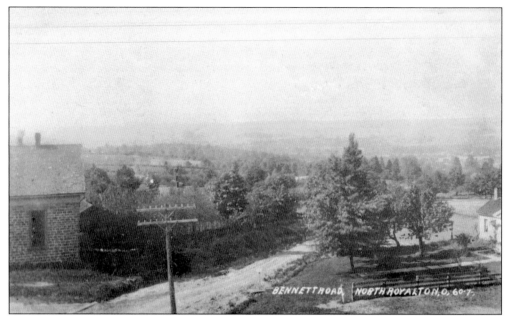

BENNETT ROAD. This 1908 postcard looks southwest down Bennett Road with the Baptist church on the left. The mailbox shown in the photograph belonged to an early home in the town. The postal service was not established in Royalton until around 1825. Curbside mailboxes were first used in Europe in the early 1800s as a sign of prestige by the wealthy. (Courtesy of North Royalton Historical Society.)

BAD WEATHER. On April 10, 1910, a late-season snowstorm dropped five inches of snow on North Royalton. Early settlers relied on the road conditions in order to survive, and many times trips had to be delayed because of bad weather or unfinished roads, making them longer than they already were. (Courtesy of North Royalton Historical Society.)

ROYALTON AND RIDGE ROADS. The first store in town, on Ridge Road across from the present location of city hall, was built and owned by Royal Tyler in 1827. It was a two-room log cabin measuring about 14 feet by 16 feet that sold supplies and goods needed by early settlers. (Courtesy of North Royalton Historical Society.)

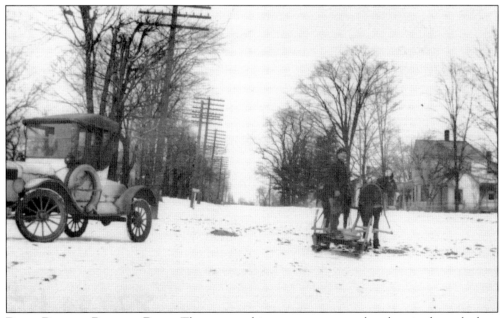

RIDGE ROAD AT BENNETT ROAD. The store at this corner was a popular place in the early days, delivering groceries by horse and buggy to residents. Grocery orders were taken the day before, and food or supplies were sent out from this spot. (Courtesy of North Royalton Historical Society.)

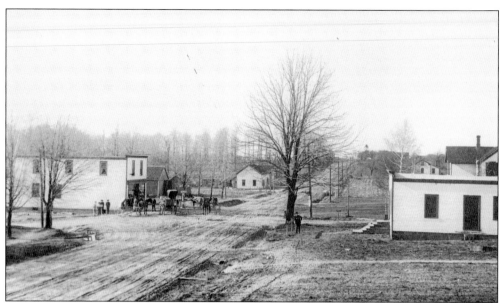

EARLY TOWNSHIP. The intersection of State and Royalton Roads used to be called the East Center. The building on the left was Cerny's General Store, constructed around 1906, and it had a hitching rail for horses and buggies out front. The building on the right was a cheese factory run by Wyatt and Searles. The above image shows the intersection in 1900; the same intersection is seen below in 1949, by which time Cerny's General Store had become Bowman's Groceries. (Above, courtesy of North Royalton Historical Society; below, Cleveland Press Collection.)

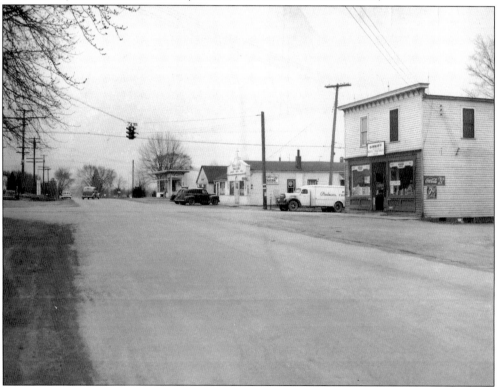

SNOWSTORM. A man fixes the power lines in a snowstorm at Royalton and Ridge Roads. Many of these early power lines fell under the weight of snow or ice. On the left is the home of Harry Loder, who hauled ice from Walter's Ice Company in Parma and provided many people in North Royalton with ice for their iceboxes. (Courtesy of North Royalton Historical Society.)

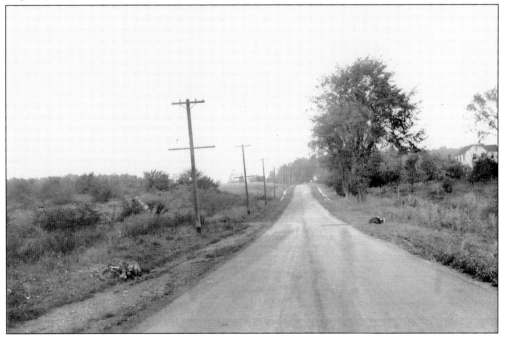

EARLY INTERSECTION. This photograph was taken at the intersection of Drake and Bennett Roads in 1942. When people started arriving in the area, the township needed to build more schools instead of teaching children in homes, and the first schoolhouse was a one-room log building located at Pritchard's Corners, near here at the corner of Bennett and Edgerton Roads. (Courtesy of Cleveland Press Collection.)

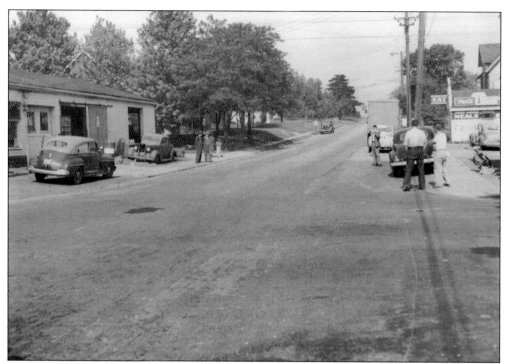

ROYALTON AND RIDGE ROADS. As communities grew, small, two-lane roads were reconstructed and widened to accommodate traffic needs. This image shows Royalton and Ridge Roads, the area previously known as the Business Center, in 1947. (Courtesy of North Royalton Historical Society.)

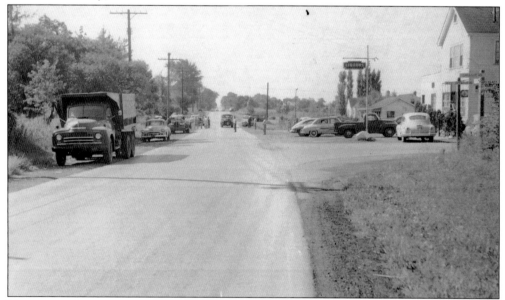

UNFINISHED INTERSECTION. The intersection of York and Sprague Roads is seen here in 1952 before Sprague Road was cut through. Sprague Road was named for early settlers David and Knight Sprague even though the Sprague families settled in the southwest part of the township. (Courtesy of North Royalton Historical Society.)

BUNKER INTERSECTION. The intersection of Ridge and Bunker Roads is seen here in 1958. Bunker Road was named for Jonathan Bunker, who came to Royalton in 1817 and started the first nursery. Many of the roads were named after the person owning the largest amount of land in the area. (Courtesy of North Royalton Historical Society.)

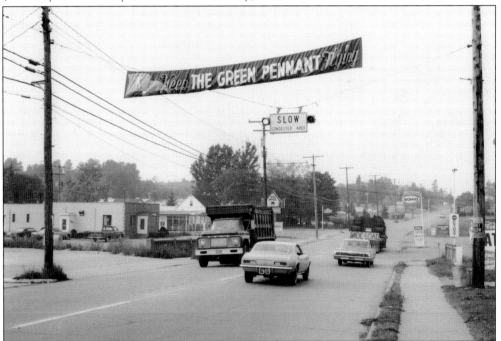

FLYING THE GREEN PENNANT. This image shows State and Royalton Roads looking west. The first building on the left was Steve and Jo's Bar in 1950 and later Gurin's Supermarket. Simandl's Sohio gas station is on the right. Mom's Restaurant was next to the gas station, where Burger King is today. (Courtesy of North Royalton Historical Society.)

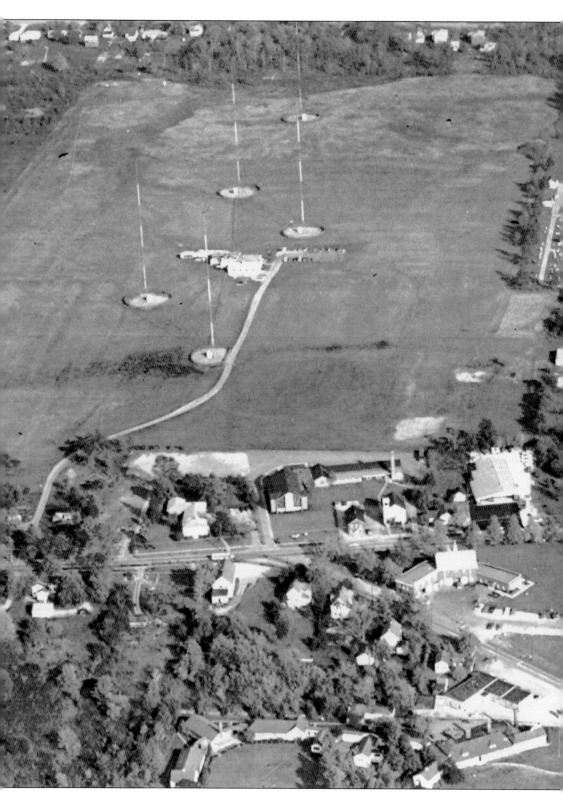

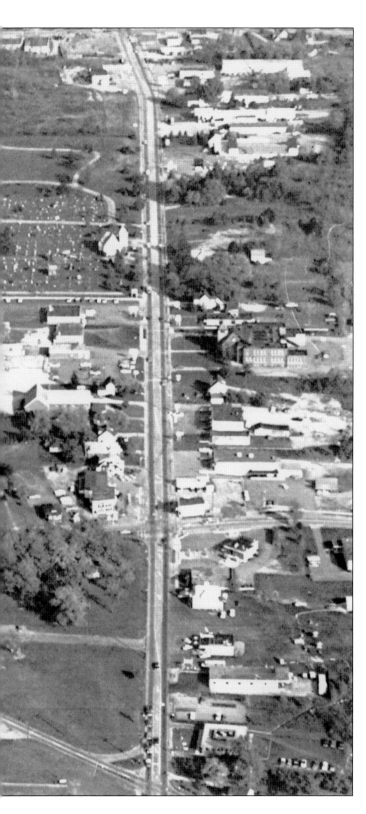

AERIAL VIEW, 1950S.
The WJW station towers, between Ridge and State Roads behind the cemetery on Royalton Road, are in the upper left. The white building in the lower right corner housed the old library on Royalton Road. At the bottom of the image is the McLaughlan home, which is now Mount Royal Villa. The V-shaped building just above it is city hall. Royalton Road is shown on the right half of the photograph vertically. In the right center, Royalton Road School can be seen. (Courtesy of the Mayer family.)

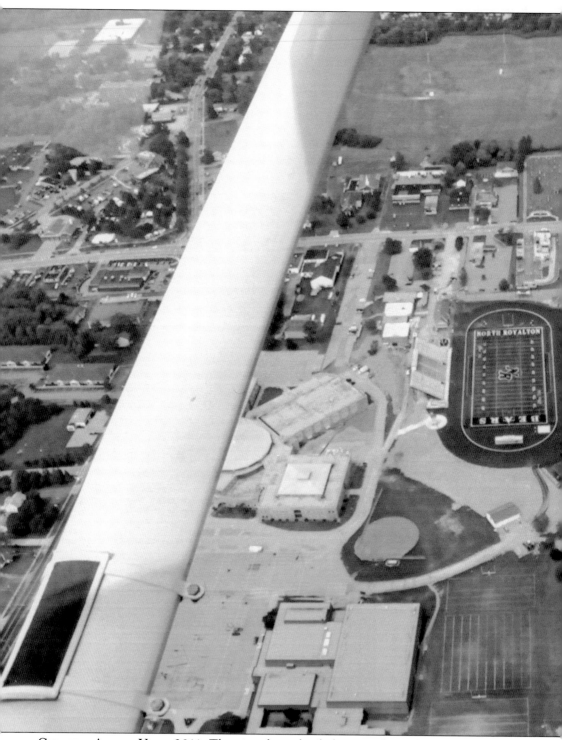

CURRENT AERIAL VIEW, 2011. The view from this helicopter shows Serpentini Chevrolet Stadium and Gibson Field. To the left of the stadium is the middle school, and below that is the high school. At the top of the photograph are the WJW station towers, and Royalton Road is

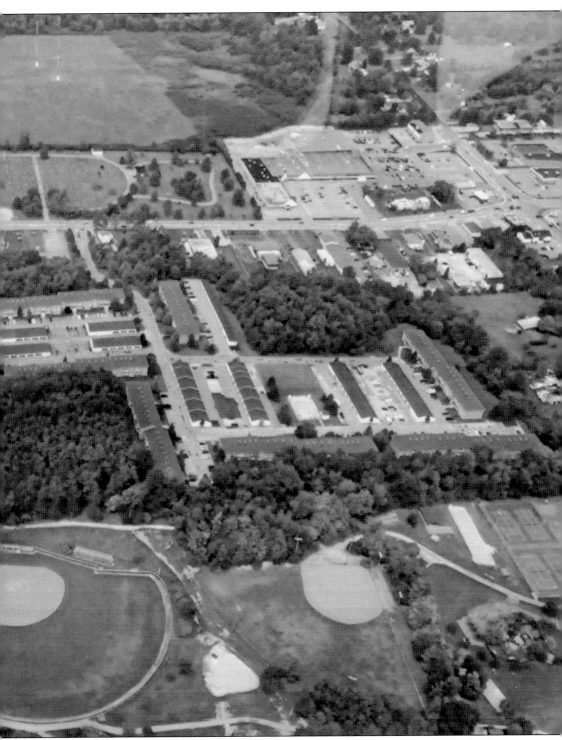

the main road running horizontally. With a mixture of traditional and modern style, the city has expanded greatly compared to the aerial view on the previous page taken 60 years earlier. (Courtesy of North Royalton School District.)

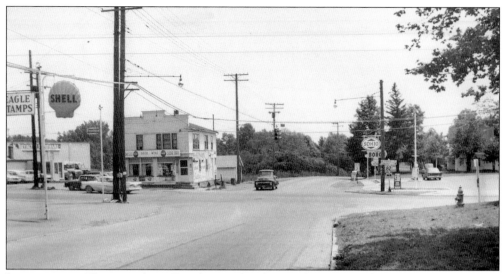

INTERSECTION. This view shows Royalton and Ridge Roads in 1960. The white building, Harry and Berny's, was previously Bert Veber's store. Next to this building is Royalton Hardware, which still stands today as Ace Hardware. Past the white building is the high school. (Courtesy of Cleveland Press Collection.)

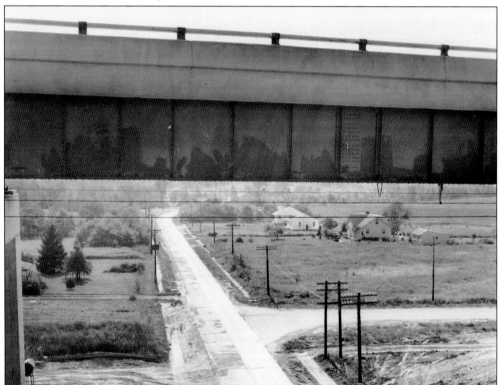

HIGH FILL OVER RIDGE ROAD. The 1955 turnpike going through North Royalton went over Ridge Road. Ohio turnpikes date back to 1815, when a man on horseback was charged 2 1/2¢ to travel on one for a shorter route. By 1955, the price of using the turnpike was around 10¢ for 10 miles. (Courtesy of Cleveland Public Library Photograph Collection.)

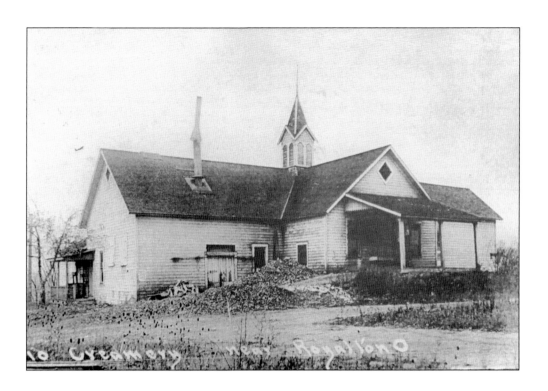

ROYALTON CREAMERY, 1866. Royalton was once known as a major dairy town because it produced large quantities of milk and later for its cheese manufacturing. There were three creameries in Royalton that hauled their products to Cleveland to be sold. Above is Royalton's second creamery, at York and Bennett Roads. Below, Ed Geiss hauls milk to Wyatt Creamery. (Courtesy of North Royalton Historical Society.)

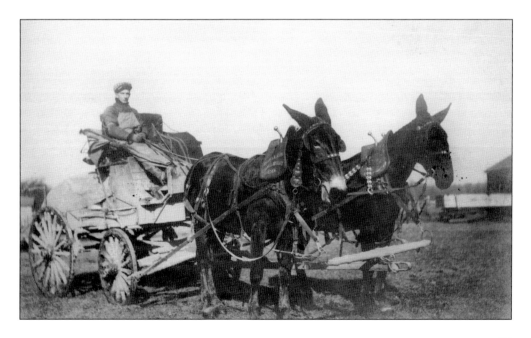

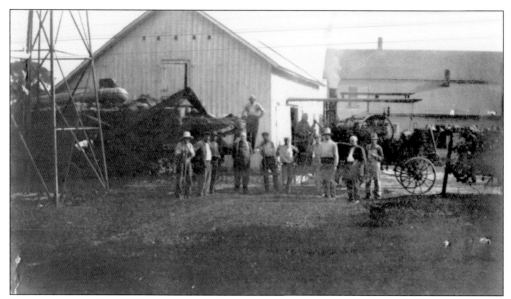

THRESHING. Part of the harvesting process, threshing separated the grain from the stalks and husks. These men stand next to the thresher machine in front of the Fieldhouse home on State Road. Prior to the house being built, a brick schoolhouse stood at this corner of Royalwood and State Roads. Royalwood used to be called Frog Road because of the many frogs living in the area. (Courtesy of North Royalton Historical Society.)

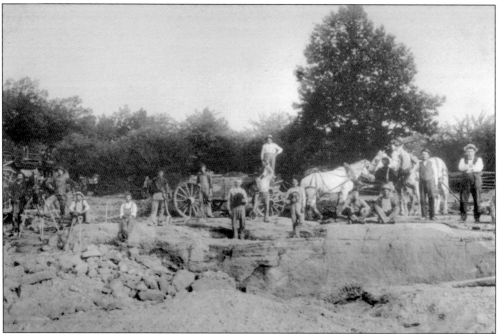

QUARRYING. There were three quarries in Royalton. Quarrying is the process of extracting stone from the ground and cutting it to make structures such as buildings and homes. Many of the homes in Royalton contain stone from area quarries, but unfortunately quarrying never took off in Royalton because there was no way to transport the stones. (Courtesy of North Royalton Historical Society.)

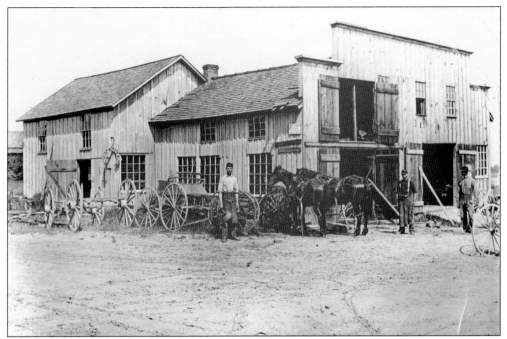

BLACKSMITH SHOP. This blacksmith and wagon shop at Albion and Ridge Roads was owned by Wayland Edgerton, who shoed horses and mended wagons and chains. He was proficient in any type of ironwork, which was a valuable skill to have at the time. (Courtesy of North Royalton Historical Society.)

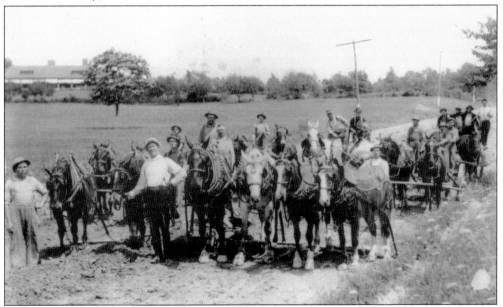

EARLY ROAD CREW. This crew gets ready to scrape and grade Royalton Road. Road scraping and grading was a continuous and necessary job to make the roads usable after winter ruts and spring muds. The large building in the background was the summer home of millionaire William McLaughlan, which is now Mount Royal Villa. Shown here are foreman Joe Bena as well as Claude Edgerton and Follen Veber. (Courtesy of North Royalton Historical Society.)

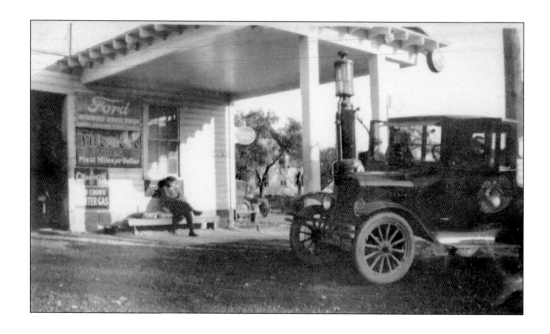

RUMMERY'S GAS STATION AND GARAGE. Most likely the first gas station in Royalton, this station on the corner of Ridge and Royalton Roads was owned by Mr. Rummery. In the early 1900s, gasoline prices were around 10 to 15¢ per gallon. Most gas stations around this time were small canopied buildings with a few gas pumps and an attendant. Above, Rummery sits on a bench waiting for customers. Below is a back view of the garage. (Courtesy of North Royalton Historical Society.)

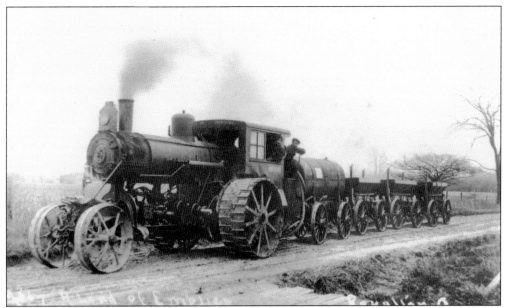

ROYALTON TRAIN. The back of this postcard mailed in May 1909 reads, "This engine hauls bricks for the State Road." That year, State Road became the first paved street in North Royalton. The bricks on this engine were brought from Berea. (Courtesy of North Royalton Historical Society.)

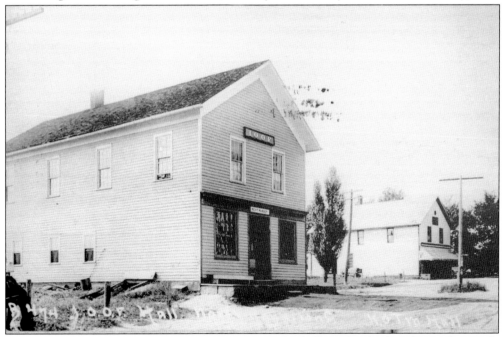

INDEPENDENT ORDER OF ODD FELLOWS HALL, 1905. This hall was first built at the north triangle of the village green, and the second floor was the lodge room used for meetings and dances. The first floor was a meat market store for many years. In 1911, the building was moved north of the Methodist church on Ridge Road. The meat business continued to run, and in the 1920s a wagon driven by Claude Veber delivered fresh meat to residents. This building was torn down in 1968. (Courtesy of North Royalton Historical Society.)

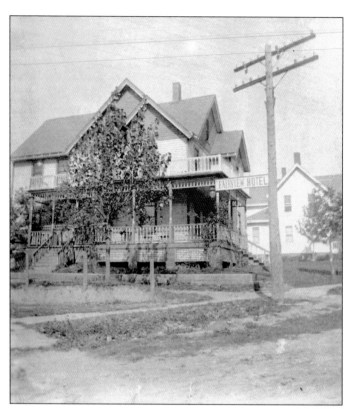

FAIRVIEW HOTEL. In the late 1800s, a Mrs. Fairfield owned this hotel on Bennett Road near Ridge Road. It was built by Charles and Horace Edgerton, and weary travelers often stayed the night for sleep and meals. Both the hotel and the Veber house next door are still standing. (Courtesy of North Royalton Historical Society.)

J.N. VEBER STORE, C. 1880. Located at the corner of Ridge and Bennett Roads was J.N. Veber's store. Veber took it over from Thomas Coates in 1872 and put up this building in 1882. It later became Gortner's store and, after that, Averill's. (Courtesy of North Royalton Historical Society.)

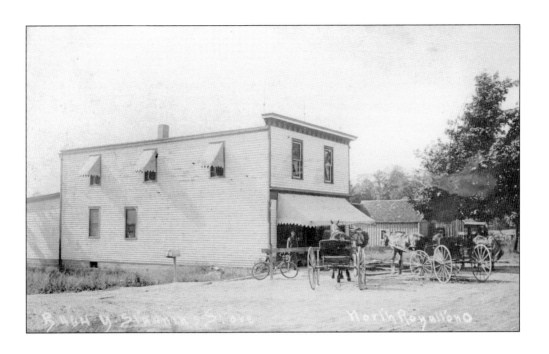

STADNIK GENERAL STORE. In 1906, a store was built by Yaro Stadnik at the corner of State and Royalton Roads. The store sold clothing, shoes, food, candy, tobacco, sewing supplies, balms and ointments for aches and pains, hardware supplies, and gasoline. The cash register held more than just money; it contained all of the accounts of the customers, which were often paid off when their farm produce was sold. Both of these images are from the early 1900s. Below, Stadnik is on the far right. (Courtesy of North Royalton Historical Society.)

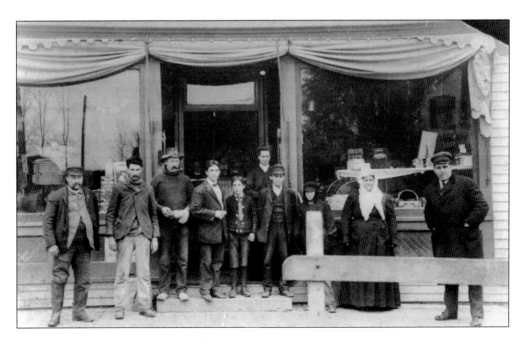

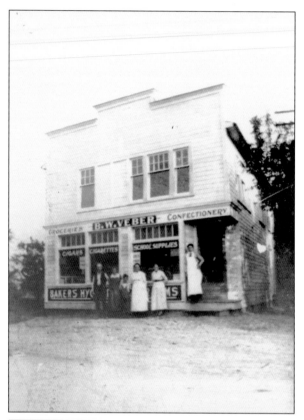

VEBER'S GENERAL STORE. This grocery store and confectionery was built by Bert Veber around 1907 at the southeast corner of Ridge and Royalton Roads. The Vebers ran the store until the early 1930s, when it was sold to new owners who added medicine, a soda fountain, and beer. In 1944, the building was sold to Berny Claridge, who turned it into Harry & Berny's. It changed hands again in 1976. To the left, Kate and Bert Veber stand in front of their store shortly after it opened. Below, the Vebers are seen inside their store. (Courtesy of North Royalton Historical Society.)

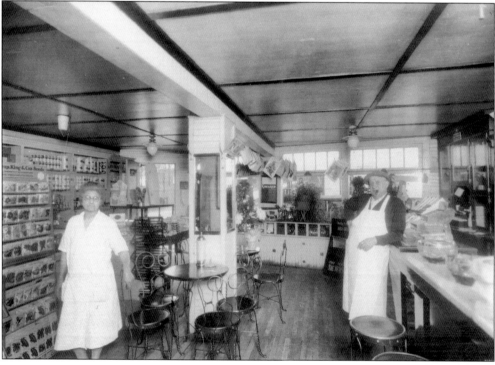

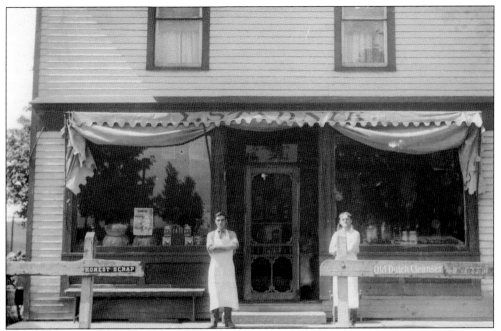

GENERAL STORE. Yaro Stadnik sold his general store to Edward Cerny (right), who ran it until 1970. The store was eventually torn down for the construction of the Sunoco gas station. (Courtesy of North Royalton Historical Society.)

OLD GAS STATION. This early one-pump gas station was on State Road near Wiltshire Road. When bigger gas stations started arriving in Royalton, this station closed and was a fruit stand for many years before it was finally torn down. (Courtesy of North Royalton Historical Society.)

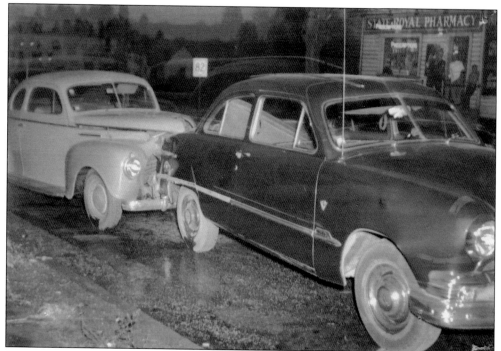

EARLY GENERAL STORE. The State Royal Pharmacy is in the background of this 1952 photograph taken from the corner of State and Royalton Roads. The pharmacy opened around 1949 and was the first drugstore in the area. (Courtesy of North Royalton Historical Society.)

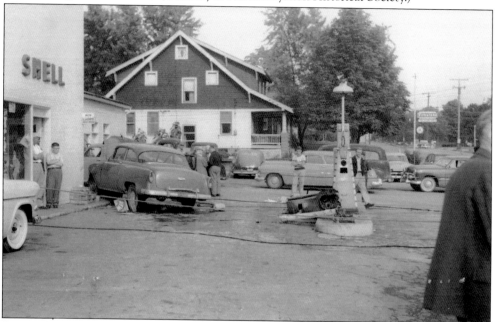

SERVICE STATION. In 1954, when this Shell station at the corner of Royalton and Ridge Roads was built, North Royalton's population was around 4,000, and it was quickly becoming a popular area. A year later, the turnpike was added through the middle of town. (Courtesy of North Royalton Historical Society.)

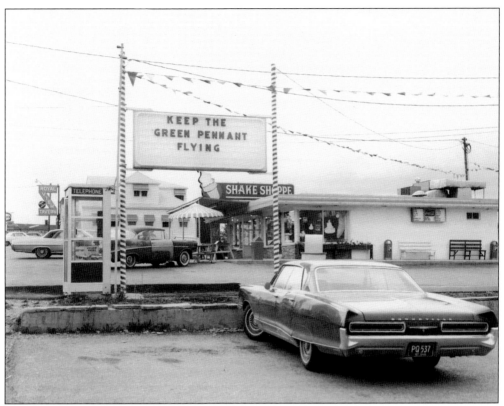

Loder's Shake Shoppe. Harry and Doris Loder opened this business at 6981 Royalton Road in 1952. It was originally a Dairy Queen, but Loder wanted to become independent and offer a variety of foods. Today, Loder's Shake Shoppe is the oldest business in North Royalton and is still family owned and operated. Harry Loder was mayor of North Royalton from 1971 to 1979 and the co-owner of Broadview Bus. At right is an advertisement for Loder's Dairy Queen in the *Royalton Recorder* from March 25, 1964. (Courtesy of North Royalton Historical Society.)

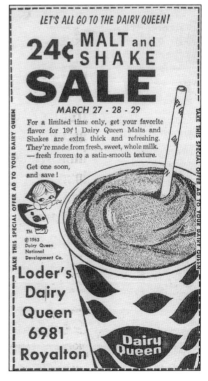

LET'S ALL GO TO THE DAIRY QUEEN!

24¢ **MALT** and **SHAKE**

SALE

MARCH 27 - 28 - 29

For a limited time only, get your favorite flavor for 19¢! Dairy Queen Malts and Shakes are extra thick and refreshing. They're made from fresh, sweet, whole milk. —fresh frozen to a satin-smooth texture.

Get one soon, and save!

TM
©1963
Dairy Queen
National
Development Co.

TAKE THIS SPECIAL OFFER AD TO YOUR DAIRY QUEEN

Loder's Dairy Queen 6981 Royalton

Dairy Queen

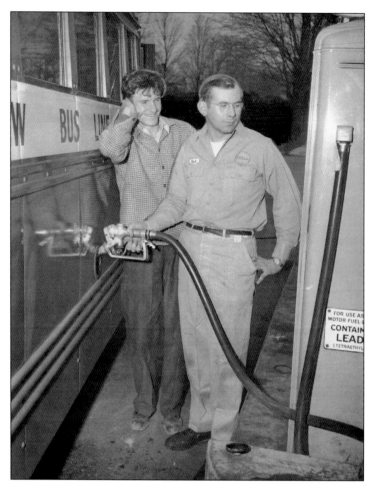

FUELING UP. Harry Loder (left) and Robert Breyley, co-owner of the gas station and the second fire chief of North Royalton, fuel up a bus in 1949. Robert's relative Elmer Breyley was the first fire chief in North Royalton. (Courtesy of Cleveland Press Collection.)

Free Orchids
during
Open House April 9 - 10
BEACON HILL
FLORIST
and Greenhouse
11450 Ridge Rd. BE 7-5126

BEACONHILL FLORIST AND GREENHOUSE. Opened in 1953 by Leo and Irene Saniuk, Beaconhill is still a family owned and operated business on Ridge Road—the second oldest business in North Royalton. This advertisement appeared in the *Royalton Recorder* in the 1960s. (Courtesy of North Royalton Historical Society.)

Averill's Self-Serve

13630 Ridge Road
Tel. BEacon 7-7300

Meat

Swift's

Bacon Oriole Brand - - - - - - lb. 59c

Beef Roast Rolled Rib - - - - lb. 98c

Assorted Cold Cuts - - - - lb. 69c

Potato Salad - - - - - - - carton 39c

Produce

Fresh Green Cabbage - - - lb. 8c

Yellow Bermuda Onions - lb. 10c

Red Radishes - - - - - - bunch 5c

Mushrooms, ½ lb. box - - - - 25c

Lemons (large) - - - - 6 for 22c

California Eating Oranges - doz. 43c

Frozen Foods

IVORY SNOW
GET SPECIAL PACKAGE HERE
10c Coupon on this package redeemable at this store.
LARGE SIZE

IVORY SNOW
2 for 55c

Orange Juice Bird's Eye - - - 2 for 33c

Lemonade Bird's Eye - - - - - 2 for 33c

Strawberries Wintergarden 10½ oz. 29c

Fryers Bird's Eye - - - - 2 lb., 2 oz. $1.49

French Fries Bird's Eye - - - 2 for 49c

Spinach Bird's Eye - - - - - - 2 for 49c

CAKE CARNIVAL OFFER
CRISCO
85c
GET DETAILS HERE

Peaches (Del Monte No. 2½ Can) --- Sliced or Halves - - 29c

Tuna Fish (Nisco in natural brine) - - - - 4 7 oz. cans $1.00

Catsup (Lady's Choice -- 8 oz.) - - - - - - - 3 for 25c

Salad Dressing (Dainty Maid) - - - - - - - qt. 39c

Marshmallows (Campfire) - - - - - - - - lb. 35c

Kool Aide - - - - - - - - - - 6 for 25c

Cracker Jack - - - - - - - - 6 for 25c

Baked Beans (No. 2½ can -- Edwards) - - - - - 19c

Oxydol or Duz - - - - - - - - - 2 large pkg. 53c

Paper Napkins (Fort Howard -- 80 count) - - - 2 for 25c

Fig Bars (Crackin Good) - - - - - - - - pkg. 38c

Saltines (Crackin Good) - - - - - - - - lb. 27c

Frostee - Lipton's - - - - - - - - - - 2/29c

Grape Juice, Welch's, 24 oz. - - - - - - - - 39c

Large Bisquick - - - - - - - - - - - - 45c

Averill's Coffee (1 lb. — 77c) (3 lb. — $2.25)

Fresh Ground Poppy Seed - - - - 49c

Cigarettes

Popular Brands

$1.88 Carton

NEW! OFFICIAL!
"SPACE CADET" GOGGLES
Only 25¢ MAILED WITH BOX TOP
For details get Kellogg's PEP today at this official "Space Cadet" store
With a Box of PEP, 17c

Candy bars

Popular Brands

6 for 25c

Tide	Cheese	Oleo	Producers
Giant - - 79c	ARMOUR'S CLOVER-BLOOM	King Nut	Ice Cream
Large - 2 for 59c	2 lb. pkg. - - 75c	19c lb.	½ gal. 98c

Cotton Club Beverages --- Ginger Ale, Root Beer and Pop

AVERILL'S SELF-SERVE. This advertisement from the June 5, 1952, *Royalton Recorder* shows the prices for Averill's Self-Serve at the corner of Ridge and Bennett Roads. Averill's sold produce, groceries, and frozen food. A pound of rib roast in the 1950s was 29¢; at the time, gasoline was around 25¢ per gallon. Around the 1900s, mom-and-pop stores were popular businesses. Chain stores started to become more common after World War I. (Courtesy of the Mayer family.)

ROYALTON MUSIC CENTER. Richard and Ida Eleck moved to the area in the 1950s, when it was all still farmland. In 1964, they started this music store, aiming to provide affordable musical instruments to new musicians. The business thrived over the years, and the Elecks opened another store in Brecksville in 1974. The Brecksville branch was sold, and more attention was given to the Royalton store. In 2011, Royalton Music Center was named one of the top 100 music stores in the country by the National Association of Music Merchants. The new store (below) opened in March 2011 at 10167 Royalton Road. (Above, courtesy of Royalton Music Center; below, Adam Rhodes.)

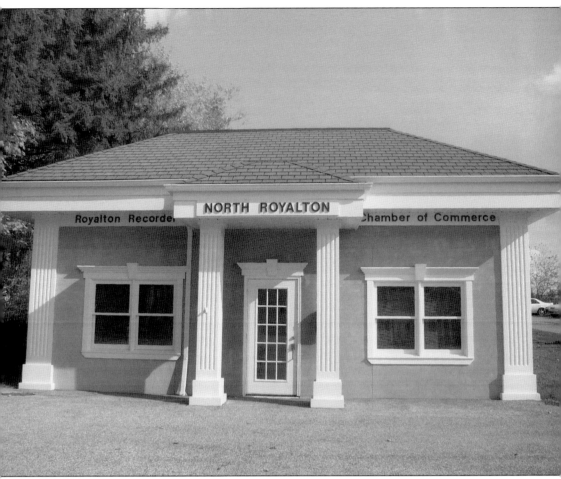

CHAMBER OF COMMERCE AND *ROYALTON RECORDER*. The North Royalton Chamber of Commerce started out as the Royalton Township Improvement Association in 1923. Its mission was to "gather and discuss ways to obtain electric light service in Royalton." The group's first action was to put road signs at the corner of Ridge and Royalton Roads. It was also responsible for organizing the Harvest Picnic each year. In 1935, the North Royalton Chamber of Commerce was created, and the first issue of the *Royalton Recorder* was printed in 1941, sponsored by the North Royalton Chamber of Commerce. Previously it had been a newsletter for chamber members, but editor Dr. John Rosenbaum wanted to promote the work of the chamber and decided to offer it to every North Royalton resident. (Courtesy of Adam Rhodes.)

FISHER FAZIO. This store was located where Giant Eagle is today in the shopping plaza at Royalton and State Roads. In 1968, when this photograph was taken, the population of North Royalton was 11,600, prompting more and more business into the area. (Courtesy of Cleveland Public Library Photograph Collection.)

CARRIE CERINO'S, 1966. Prior to Carrie Cerino's, this was the location of Schuckert's Chalet. Designed by Fred Schlensker Jr., it opened in 1949. In 1962, Carrie and Dominic Cerino walked into Schuckert's Chalet and noticed it was for sale. Dominic had a wrinkled $20 bill in his pocket and used it for a down payment on the building. The Cerinos then borrowed $165,000 from the bank to buy the building and the land, and it thus became Carrie Cerino's. A grand ballroom was added in 1972. (Courtesy of North Royalton Historical Society.)

ADVERTISEMENTS. This page from the January 7, 1954, *Royalton Recorder* lists advertisements from familiar local merchants. In 1949, Harry & Berny's added a television set in their store, which made them quite popular; many people made special trips there just to watch it. (Courtesy of the Mayer family.)

La Dean's Flowers
Telegraph Service
Corsages, Cut Flowers, Weddings, Funerals
6037 Royalton Rd. Tel. BE 7-6386

HARRY & BERNY'S
"The Family Store Where Friends Meet"
LIGHT LUNCHES FILMS
BEER AND POP BY THE CASE TO TAKE OUT
Try Our Delicious Sodas and Sundaes
Closed Mondays at 7 P. M.
Corner Royalton and Ridge Roads BEacon 7-8881

E. A. MAYER
General Trucking
CUSTOM MOWING
Lime Spread — Get Your Orders in Today
Custom Plowing and Fitting Trees Cut Down or Cut Up
Bennett Road BEacon 7-7388

N. R. Builders' Supply Co.
A full Line of Builders' Supplies
Building Blocks — Cement — Cement Topping
Sand — Lime Drain and Sewer Tile
CALL AT THE YARD AND SAVE
8 A. M. to 5 P. M., Saturdays 8 A. M. to 12 P. M.
TELEPHONE: BE 7-5571
Royalton Road just east of State Road
(Next to Sohio Station)

Royalton Radio & Appliance
6639 Royalton Road BE 7-6194
Zenith - Philco
Television Sets
Radios — Toasters — Deep Fryers — Irons — Mixers
Service on All Makes of Television

POST OFFICE, 1960. This post office on Royalton Road was used from 1958 to 1977. Before it was established, people had to pick up their mail in Cleveland, more than 10 miles away. The first post office was located in the town hall, and the first mail carrier was paid 50¢ a year. In 1949, it moved to a building on Ridge Road and finally to this location in 1958. In 1977, a new post office was built on State Road. (Courtesy of Cleveland Press Collection.)

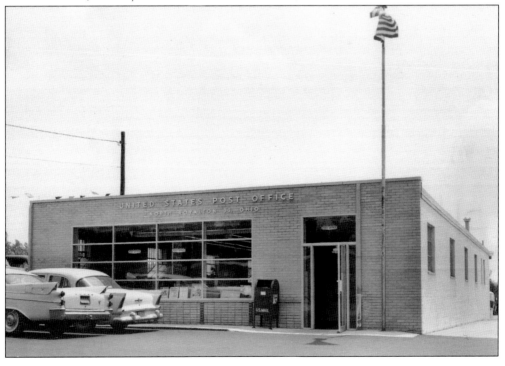

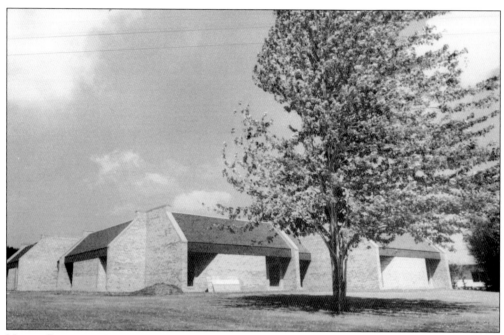

NORTH ROYALTON LIBRARY, 1978. For a long time, there was no public library in Royalton and early residents had to travel to the library in Cleveland to get books. But in 1855, a library was set up at a school building on Ridge Road. Thomas Coates was hired as a librarian, receiving a yearly salary of $11. At the time, the library had between 6 and 12 books available to borrow. Once the area became more populated and more schools were added, the library was moved around to different buildings. In 1950, it was set up in a storefront on Bennett Road across from the town hall. The current library on State Road was dedicated in 1978. (Courtesy of Cleveland Press Collection.)

FRIENDS OF THE LIBRARY. This group was first organized in 1961 by a committee of five local citizens who wanted to promote greater use of the library's facilities. Mrs. George Medas (seated) signs members of the Cangelosi family up for the newly formed Friends of the Library in 1962. They are, from left to right, Allegra, Adrea, David, Mark, Alice, and Andrew Cangelosi. Andrew was chairman of the first meeting of Friends of the Library. (Courtesy of Cleveland Press Collection.)

Five

HISTORIC HOMES

When early settlers arrived in Royalton, they used whatever they could find to make shelter, putting up shanties or lean-tos, which usually had only three walls and a sloping roof, until they could get supplies together to build something sturdier. Often, the head of the household would arrive in the area first, set up a shelter, and then prepare a living area for his family before sending for them.

Melzer Clark, the first settler, built his log cabin at the southeast corner of the township. Several years later, others arrived and erected temporary shelters until they could get enough wood together for a more permanent structure.

In the 1830s, brick homes started to replace log cabins. Wood-frame houses were also built around this time, with wood usually supplied from timber on the farm. The 1830s also brought more houses near the center of the township instead of on large tracts of land spread apart from each other. Houses valued at a few hundred dollars were considered good homes at that time.

Many of the old houses in Royalton are still around today and are called century homes. These homes were researched by the North Royalton Historical Society, and their owners were presented with plaques detailing the findings of the society.

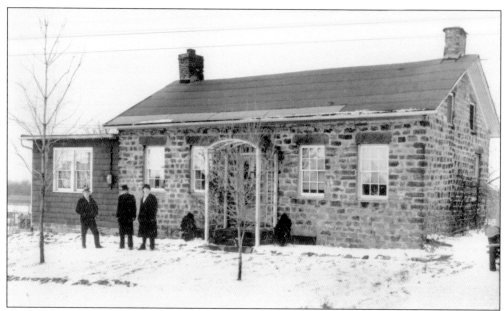

OLD STONE HOUSE. The Rennert House, also known as the Old Stone House, is believed to be the oldest house in North Royalton, dating back prior to the 1830s. A secret room inside is said to have once been used as a part of the Underground Railroad. Indian tribes settled next to a nearby spring, and a number of arrowheads were found in the backyard. In later years, many people from other cities would drive to this spring and fill jugs with clear water. A peephole, found in the attic level of the home, was most likely used as a lookout for others in the area as well as for wild game. The photographs above and below both show the Rennert House over the years. (Courtesy of North Royalton Historical Society.)

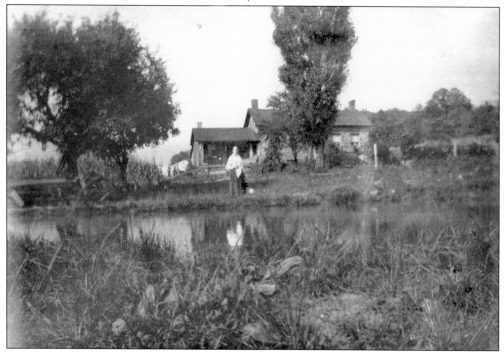

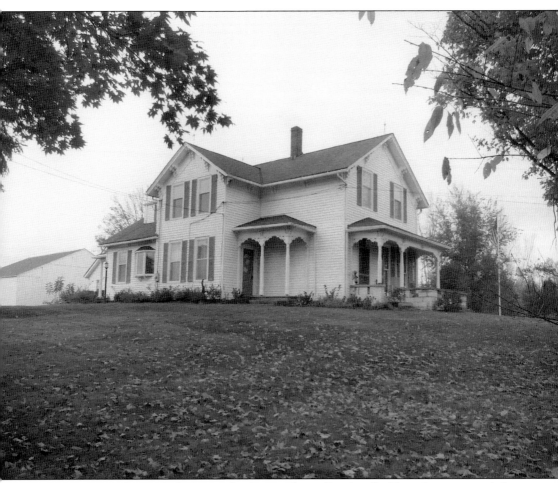

CARTER-WILMOT HOME. Seth Paine, the first settler in Brecksville Township, surveyed this land and gave it to his daughter Almira Paine and her husband, Melzer Clark, the first settlers of Royalton. They built their first homestead on this land. Now part of Broadview Heights, this was the area of the first home in Royalton Township when the township extended to Broadview Road. After Melzer's death, Almira married Lewis Carter in 1816 and had a son, Lorenzo Carter, who was the first white child born in Royalton. This house was built in 1870 on the northwest corner of Boston and Broadview Roads. (Courtesy of Susan Eid.)

VEBER HOUSE. Kate Veber stands on the front porch of the house she shared with her husband, Bert, on Bennett Road. Most houses were built with covered porches for sitting on a Sunday afternoon with family, friends, and neighbors. (Courtesy of North Royalton Historical Society.)

EARLY POSTCARD. On the right in this postcard is an earlier view of Bert and Kate Veber's house, and on the left is the Fairview Hotel. The postcard shows that the area on Bennett Road close to Ridge Road was newly built-up, with young trees growing in front of the house. (Courtesy of the Mayer family.)

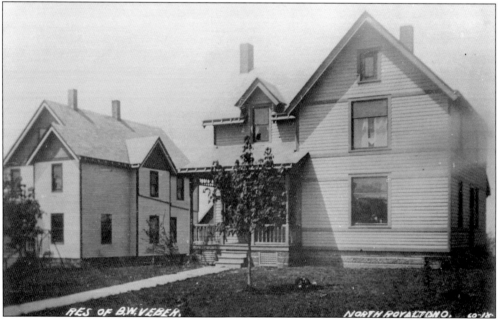

RES OF B.W. VEBER. NORTH ROYALTON O. 60-15

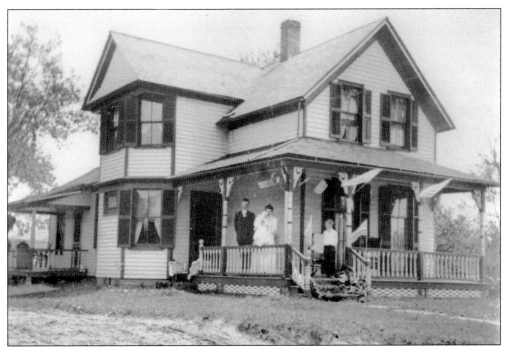

L.S. Searles House. This c. 1870 photograph shows the Searles house at the corner of State and Royalton Roads. The house was owned by Lambert Secretary Searles and later became the Searles and Bassett Funeral Home, the first of its type in Royalton. This building was torn down when Rite Aid was built. (Courtesy of North Royalton Historical Society.)

Kellum Residence. Dr. Monford Kellum's home near the center of town was also his office, opened in the 1920s. Dr. Kellum owned the first automobile in town. The first doctor in Royalton was Henry Hudson, who came to the area in 1818. At the time, doctors usually charged $2 for a house call and $35 to deliver a baby. (Courtesy of North Royalton Historical Society.)

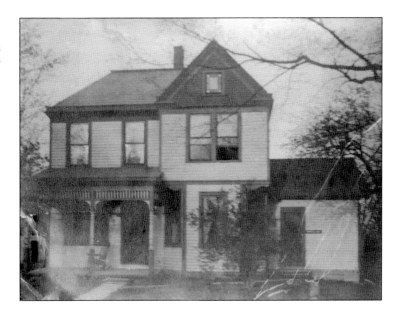

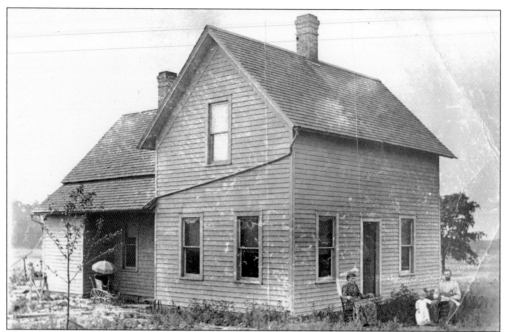

EDGERTON HOME. George Stanley Edgerton and his wife sit outside their home at 9874 Ridge Road. George was born in 1870 in Royalton and his son Lester Edgerton, the mayor of North Royalton from 1930 to 1968, was born in this house in June 1892. (Courtesy of North Royalton Historical Society.)

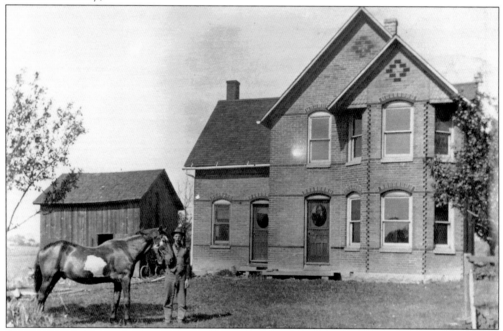

SHERWOOD HOME. In this postcard, Herb Sherwood stands with his horse in front of his home. The Sherwood brothers had a tollgate at the corner of Wallings and State Road and charged travelers 35¢ per round trip. If people were traveling to church or court, they were not required to pay the toll. (Courtesy of North Royalton Historical Society.)

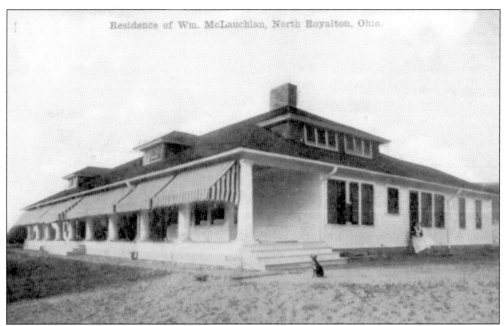

Residence of Wm. McLauchlan, North Royalton, Ohio.

ROYALTON'S FIRST MILLIONAIRE. The home of millionaire William McLaughlan, which had panoramic views of North Royalton, was built around 1909. Prize-winning roses were grown in a garden with a fountain in the center. When McLaughlan died, the house was sold and turned into a tuberculosis sanatorium in 1932. Today, the home belongs to Mount Royal Villa, a nursing home. Below is a view of the south wing of Mount Royal Villa from 1950. (Above, courtesy of North Royalton Historical Society; below, Cleveland Press Collection.)

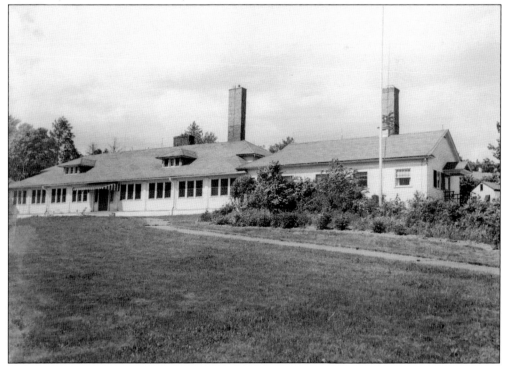

EARLY CONSTRUCTION. This house on State Road is being built in 1900. Safety was not a concern, as these men work on top of the building with little care of the danger and no protective gear. (Courtesy of North Royalton Historical Society.)

WILLIAM STOCKMAN HOME. At the southwest corner of Wallings and Ridge Roads, the Stockman homestead at 12014 Ridge Road was built in 1834. According to an 1836 township map, William Stockman, who was postmaster and township trustee for many years, owned this land as well as land on the east side of Ridge Road. (Courtesy of Adam Rhodes.)

Sardis Edgerton Homestead. Built in 1855 by Sardis Edgerton Sr., this home at 3998 Edgerton Road was the location of one of the first steam sawmills in Royalton. It was also the first in the township with running water; an underground pipe from a spring in a ravine near the house ran into a large box in the kitchen and living room. Also on the property was a large sugar bush, where over 1,000 sugar maple trees were tapped each spring. (Courtesy of Adam Rhodes.)

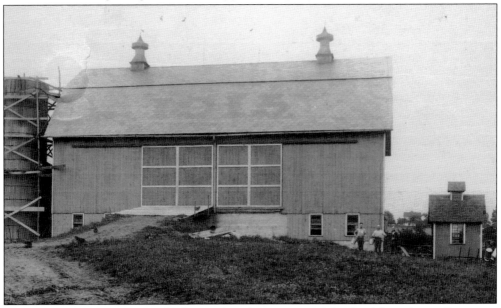

Edgerton Farmhouse. Samuel Edgerton bought a portion of this land from Aaron Granger, a relative of a Connecticut Land Company investor. Everyone in the Edgerton family had a part in building this barn, as there were many masons and carpenters among them. (Courtesy of North Royalton Historical Society.)

TEACHOUT HOMESTEAD. This home was built in the late 1830s by the Teachout family. Abraham Teachout Sr. came to Royalton with his family in 1837. Abraham Teachout Jr., a temperance advocate, preached to his fellow neighbors and workers that they needed to work without liquor. He was also a close friend of James A. Garfield. The small windows at the top of the house provided light for the second floor, and the home had three chimneys for potbelly stoves. (Courtesy of Susan Eid.)

JONATHAN BUNKER HOMESTEAD. Jonathan Bunker came to Royalton in 1817 and settled on Bunker Road. He was related to the historic family for which the Battle of Bunker Hill in Boston was named and was an experienced rope maker, supplying Cleveland with most of the white rope used there. The first marriage in Royalton was that of Bunker's daughter Lovey Bunker to Asa Norton. Bunker also built the first frame dwelling in Royalton in 1827, which was destroyed by fire and replaced with this current home. (Courtesy of Adam Rhodes.)

JOHN COOK HOMESTEAD. John Cook came to Royalton in 1845 and built the original part of this home at 18567 State Road one year later. Old stories recall a curved driveway coming up to the front door where early stagecoaches stopped. A stagecoach arriving was a big deal back then, and many people dressed in their best clothes for the event. (Courtesy of Susan Eid.)

JOHN HALL HOMESTEAD. This home on Royalwood Road was built in 1830, but the property goes back to the 1820s when an early settler named Royal Tyler put up a building there for $1,100. Maps from 1838 show John Hall, a Revolutionary War veteran buried in the North Royalton Cemetery, as the owner of the property. There were three fireplaces in the home: one at each end and another in the summer kitchen. (Courtesy of Doris Coleman.)

HENRY AKINS HOMESTEAD. This home at the corner of Akins and State Roads was built around 1849. Henry Akins was born in 1814 in Connecticut and moved with his wife, Mercy, to Royalton, where they raised nine children. The bricks for this home were brought by oxen from a kiln located on State Road near Edgerton Road. (Courtesy of Adam Rhodes.)

CHARLES RUMMERY HOMESTEAD. Charles Rummery was born in England in 1813 and came to Royalton in 1841. This house was built in 1852 in the Greek Revival style. Rummery first built a log cabin on the site around 1843 but replaced it with this home around 1862, possibly firing the bricks for the home on the site. (Courtesy of Adam Rhodes.)

R. PRISKE HOMESTEAD. Built in 1869, this home was originally owned by R. Priske, whose daughter played the organ for the North Royalton Methodist Church at its first location on Wallings and Ridge Roads. The Mayer family currently owns this home, and the addition on the left was added in 1982. (Courtesy of the Mayer family.)

JOHN M. ANNIS HOMESTEAD. This home, built in the early 1830s at 9271 State Road, was placed on the National Register of Historic Places in March 1992. In 1855, it was valued at $300. This property was owned by the Annis family from 1825 to the 1960s. (Courtesy of North Royalton Historical Society.)

SMITH/RUTLEDGE HOMESTEAD. This 1858 home is now the North Royalton Historical Society. It was first known as the Smith house, and in 1991 it was owned by church member Pearl Rutledge. The historical society was formed in 1976 to preserve the history of the city, and the home, at 13759 Ridge Road, is across from city hall. The interior, shown below, contains various items of North Royalton history that have been collected and donated by residents and members of the historical society through the years. (Above, courtesy of Adam Rhodes; below, North Royalton Historical Society.)

CLARK GIBBS HOMESTEAD. Located at 18730 Ridge Road, this house was built by Benjamin Gibbs. His son Clark Gibbs learned the wagon-making trade and made them for many years. He also bought a mill in 1847 opposite this homestead. After rebuilding the mill in 1849, he was the only operator of the mill, which stayed in operation into the early 1900s. (Courtesy of Susan Eid.)

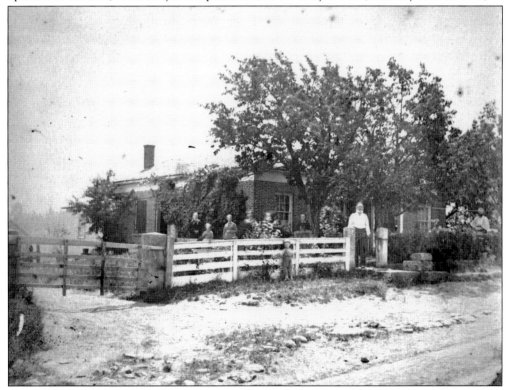

WILCOX HOME. Posing around their home on Wallings Road around 1878 are, from left to right, (behind the fence) Grandma Jaycox, Nettie Wilcox, Sarah Wilcox, Grandma Jane Wilcox, Edwin Wilcox, and Grandpa Wilcox (on the far right); the little boy in front of the fence is Orin Wilcox, and Archie Wilcox is in the baby carriage. (Courtesy of Adam Wolfe.)

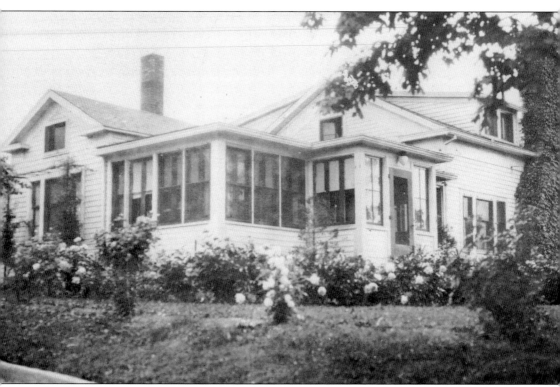

OLD MINER HOMESTEAD. This home was on State Road opposite Bunker Road. Owner John Miner came to Royalton around 1832 and purchased 80 acres of land for $10. After he died in 1840, his son Daniel took over the farm. Around 1929, it was sold to Charlie McCombs, the first mayor of Royalton, and over the years many additions were made to it. (Courtesy of North Royalton Historical Society.)

BIBLIOGRAPHY

Marcis, T. Richard, ed. *North Royalton, Ohio, 1818–1968*. H.W. Hill Printing Co., 1968.

North Royalton Historical Society. *The History of North Royalton, 1811–1991*. Brunswick, OH: King's Court Communications, Inc., 1992.

DISCOVER THOUSANDS OF LOCAL HISTORY BOOKS FEATURING MILLIONS OF VINTAGE IMAGES

Arcadia Publishing, the leading local history publisher in the United States, is committed to making history accessible and meaningful through publishing books that celebrate and preserve the heritage of America's people and places.

Find more books like this at
www.arcadiapublishing.com

Search for your hometown history, your old stomping grounds, and even your favorite sports team.

Consistent with our mission to preserve history on a local level, this book was printed in South Carolina on American-made paper and manufactured entirely in the United States. Products carrying the accredited Forest Stewardship Council (FSC) label are printed on 100 percent FSC-certified paper.

MADE IN THE
USA